Practical Effects in Photography

The Practical Photography Series

Practical Composition in Photography Axel Brück
Practical Exposure in Photography Leonard Gaunt
Practical Effects in Photography Carl Bernard & Karen Norquay
Practical Wildlife Photography Ken Preston-Mafham

Carl Bernard & Karen Norquay

Practical Effects in Photography

Focal Press London & Boston

Focal Press

is an imprint of the Butterworth Group

which has principal offices in

London, Boston, Durban, Singapore, Sydney, Toronto, Wellington

First published 1982

© Carl Bernard and Karen Norquay, 1982

British Library Cataloguing in Publication Data

Bernard, Carl
 Practical effects in photography. – (The practical series).
 1. Photography – Special effects
 I. Title II. Norquay, Karen III. Series
 778.8 TR148

 ISBN 0-240-51082-8

Printed in England by Clout & Baker Ltd, Maidstone, Kent

Contents

Acknowledgement

Karen Norquay gratefully acknowledges the help of Kenneth Stubbs in producing colour prints.

Introduction

This book shows what it is possible to achieve in the way of alternative imagery by the use of conventional, everyday photographic materials. The contents are a compilation of techniques and processes that originated from, or were applied to, existing works by the authors over a period of five years or more.

When experimenting or improvising with light-sensitive materials, the value of a working knowledge of the principles of photographic procedure should never be underestimated. The greater the understanding of such a wide-ranging and complex subject, the more chance one has of success when it comes to the later stages of image 'development'. A photographer also has to be very discerning when it comes to the prior considerations of omission, inclusion and general arrangements of the image. One has to be reasonably satisfied that, at the instant the shutter is released, all technical and aesthetic factors have been taken into account. Only then can one expect to produce negatives that will be the basis for creating satisfactory photographic images.

Many photographers extend their craft to convey a more personal or esoteric impression of their model or subject. Although we believe and state in the main text that the most important consideration is indeed subject matter, it is only briefly and occasionally referred to. Everyone has personal criteria concerning original imagery, so it was considered more important to stick to objective and factual observations concerning materials and procedures involved in the production of the prints.

The visual content, it is hoped, will provide reference for effect and impression and together with the text be of use to those who wish to use the medium of photography in a way they may not have considered before or as a source of practical alternatives for photographic printmaking.

C. B.

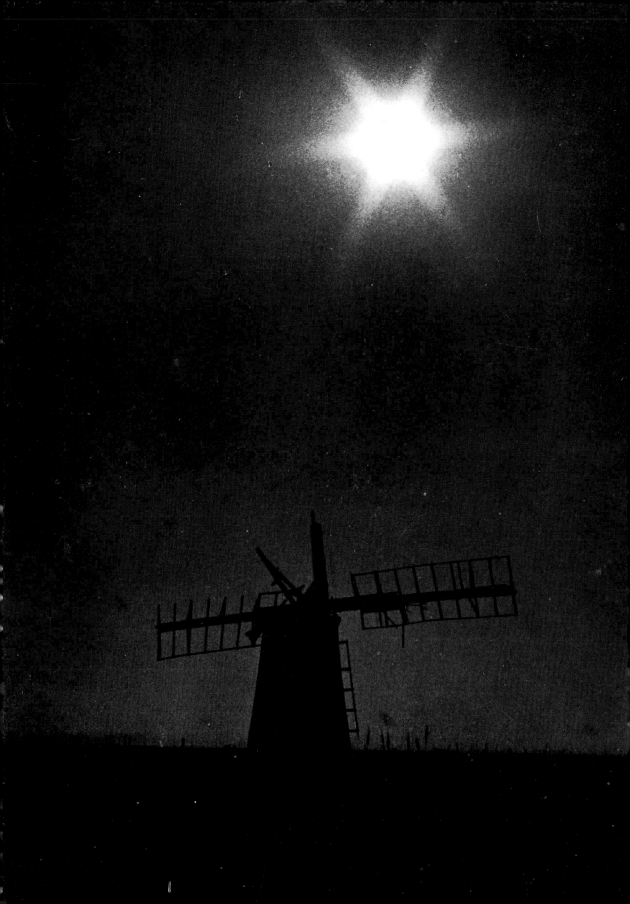

1
The Camera

Introduction

The most popular and versatile camera is the single-lens reflex, which uses the same lens for viewing and recording the subject. A hinged mirror behind the lens reflects the image onto the focusing screen. When the release button is pressed the mirror is moved out of the way, exposing the film to light, and then moved back, restoring the image to the screen. The lens can be stopped down manually to check depth of field while viewing, and stopped down automatically for exposure. Unlike the twin-lens reflex, SLR cameras have no parallax problems and can therefore be used for very close work. SLR cameras generally take 35mm film, but roll-film models are also available.

Besides the quality of the lens, two other facts affect the type of picture taken: focal length and aperture. The focal length indicates the distance between the film and the centre of the lens when distant objects are focused. It represents the light-bending power of the lens. The aperture controls the amount of light passing through the lens to the film. The aperture ring is marked in f numbers, eg 2.8, 4.5, 5.6, 8, 11, 16, 22. More light passes through at $f4$ than at $f22$. Changing the stop from $f5.6$ to $f8$ halves the amount of light passing through the lens; changing from $f11$ to $f8$ doubles the amount of light. The size of the aperture also determines how much of the subject is in focus, ie the depth of field. The nearer the lens is to a subject or the smaller the f number, the less the depth of field.

For a large range of picture types, interchangeable lenses are essential. One should aim to have a wide-angle lens, with a short focal length and an angle of view greater than the eye; a standard lens, with a 45° angle of view; and a telephoto lens, with a long focal length, giving a larger image of a distant object than a standard lens but with a smaller angle of view.

For the correct exposure of the film in the camera, a light meter of some sort must be used. Some cameras have built-in meters. Such devices work well when more or less equal amounts of light and shadow are involved, but a dark subject against a light background might be underexposed. A separate light meter that can give more critical readings is then useful.

The list of additional equipment for taking photographs is almost endless, although many of the illustrations in this book were made with very ordinary items. There is, however, no substitute for familiarity with what equipment one has, and almost no limit to experiment once it is understood.

<div style="text-align: right">K. N.</div>

Silhouette

The photograph of the windmill was taken facing directly into a bright sun at midday. The desired effect was the windmill and landscape in silhouette with the sun an emphatic star shape in the sky.

When photographing in these conditions, the larger the lens aperture the more circular and diffuse the light-source will become. When the sun is focused off centre or even just outside the picture frame, however, iris flare can occur. Iris flare is made up of diaphragm shapes apparently radiating from the sun and is actually a reflection from the glass surfaces in the lens. The more surfaces there are in the lens, the greater the number of diaphragm shapes.

The sun was distanced by the use of a wide angle lens. A light reading was taken from the brightest point in the picture. The chosen setting was *f*22 at 1/250sec.

The resultant negative registered the bright star shape of the sun but there was no detail in the dark areas. When printing dark areas of a picture, ie the lightest part of the negative, care should be taken to ensure all fluff is removed; every speck will show up and the 'snow storm' effect means many hours will have to be spent spotting.

A print was made on a normal grade of printing paper. A minor degree of iris flare was lost in the very black foreground and dark sky.

Sunlight Effects

The most dramatic cloud formations are usually seen at dawn or dusk and before or after a storm. The shafts of sunlight coming from behind dark clouds can make a striking picture. Care must be taken not to overexpose the film as this may ruin the overall effect.

It is advisable to use an ultraviolet-absorbing filter when photographing distant landscapes. This counteracts the haze caused by ultraviolet radiation which though invisible to the eye affects photographic materials. Such a filter has no effect on camera exposure.

To record the dewy misty atmosphere of dawn in this photograph a UV filter was not used as it would have eliminated most of the haze. The tree was framed deliberately in the middle distance to spread the sun rays over the foreground. Wet, icy or shiny surfaces take on a silvery or gold appearance

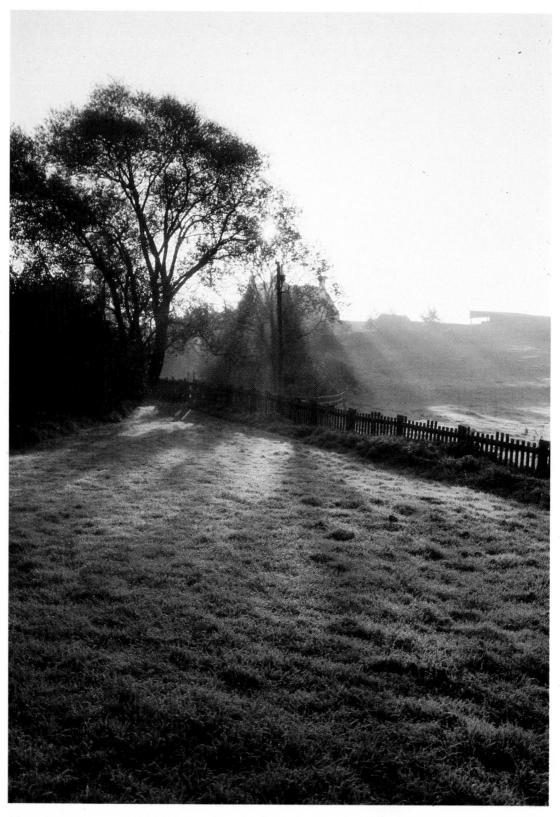

when shot in direct sunlight. A lens hood must be used to reduce flare when shooting directly into the sun.

Low harsh light can be unusually exciting. The kiosk in Brighton was photographed just after a shower in February. The sun was low in the sky, throwing long, intense shadows and producing bright rich colours. The general light meter reading was *f*11 at 1/125sec but the photograph was underexposed by two stops to *f*22 at 1/125sec. The underexposure intensified the colours still more.

Kodachrome 64ASA and 25ASA films are ideal when colour brilliance is the objective. These fine grained colour films, however, cannot be processed by the user. Ektachrome 200 and 400ASA films can be processed by the user. They show more grain and seem less contrasty with more subtle tones.

Selective Focusing

The photographs on pp. 14 and 15 were taken with the same 35mm camera and 50mm standard lens on a medium speed film.

The different effects were achieved by selective focusing and narrowing the depth of field. Depth of field is the area of maximum clarity before and behind the object focused on. Depth of field decreases as the lens aperture is enlarged and also as the focal length becomes longer. A 28mm lens on a 35mm camera will render much more in focus than a 135mm lens set on the same aperture. With a large aperture, one area can be sharp while the surroundings are blurred.

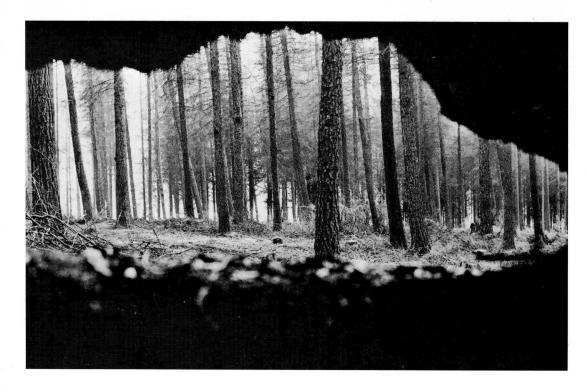

Both photographs were taken with a wide aperture (*f3.5*) but the focusing was changed.

One photograph was focused on the cold exterior leaving the cave a blurred outline. It was printed on a very hard bromide paper (Grade 4) to accentuate the coldness.

The other photograph was focused on the dry twigs in the foreground to give a warm sheltered feeling to the cave. It was printed on a soft grade of paper (Grade 2).

Once thoroughly fixed and washed, both prints were sepia toned.

Selective focusing. Effect of focusing on distant trees and printing on hard paper. *Karen Norquay.*

Stage Lighting

At first sight stage lighting seems to do everything for the photographer, but all kinds of problems are involved and there is a real need for calculation and manipulation. Special effects at the other end of the camera, ie the subject end, are in fact a whole class of problem in themselves.

If pictures are taken at what is called a 'photo-call' (a session specially for photography), then there is usually a chance to move about and find a good vantage point. More commonly, however, photographs have to be taken during the performance itself from somewhere among the audience. It is best not to take

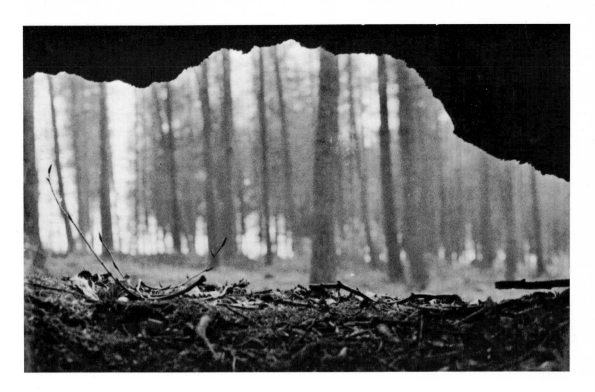

Selective focusing.
Effect of focusing on foreground and printing on soft paper. *Karen Norquay.*

pictures from below—unless there is a need for views of the performers' nostrils. On the level or slightly above are the best positions. If possible, it is worth going to see the performance beforehand to work out where to take the photographs from and what lenses and type of film will be best for the job.

A small torch is a necessity for, as a rule, the auditorium is plunged into darkness and without a light source checks on exposure and loading of the camera are virtually impossible.

Stage lighting varies enormously and, in most productions, will change every few minutes. Light meter readings can be deceptive but a spot meter is ideal for the purpose. The subject is observed through a telescopic sight and, once the shutter and film speed have been dialed in, the correct aperture is indicated.

A motordrive attachment may be necessary to take a series of photographs in fast sequence. This attachment is ideal for ballet and modern dance (as well as in sport photography) when that special picture may be lost in the time it takes to wind on the film. A word of warning: a motordrive can be very noisy and, as a lot of film may be wasted, very costly.

When using colour, an exact colour rendering is often not necessary. What is important is to convey the atmosphere of the performance.

A colour film balanced for tungsten light is required to match the colour temperature of most stage lighting.

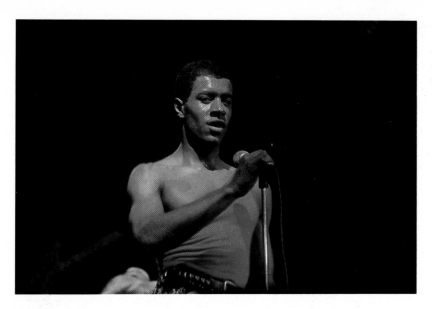

Spotlights with different coloured gels moved about the stage, constantly picking out the dancers and singers. It was impossible to use a tripod in the dark crowded night club so a fast 400ASA daylight transparency film was chosen. As the colours were constantly changing, the reproduction of the correct colours was of no consequence. The film used was balanced for daylight and was intended to add warmth. Often, when there are harsh spotlights, a general light meter reading will be inaccurate. The background will be perfectly exposed while the highlights will be grossly overexposed. In compensation, the film was underexposed by two stops.

To make the calculation of underexposure easy, the ASA setting on the through-the-lens light meter was changed from 400ASA to 1600ASA and the camera was set on the exposures then recommended. The film was processed normally, ie as if it had been rated at 400ASA.

Movement

Many different stratagems can be adopted to convey movement. It can be caught at an expressive moment or it can be recorded as a sequence of events. What is important is to learn the kind of effect associated with each method and which fits a particular subject.

Fitting the technique to the subject can be quite complicated as, of course, everything moves at a different pace. To complicate matters more, the more distant the moving subject

Movement
Opposite: Two
photographs taken on
160ASA tungsten
transparency film. For the
ballet dancers, the
exposure was for 1/60sec,
and for the conductor,
1/15sec. *Karen Norquay.*

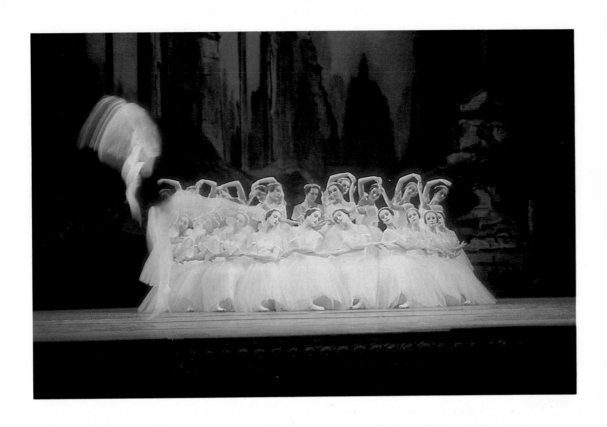

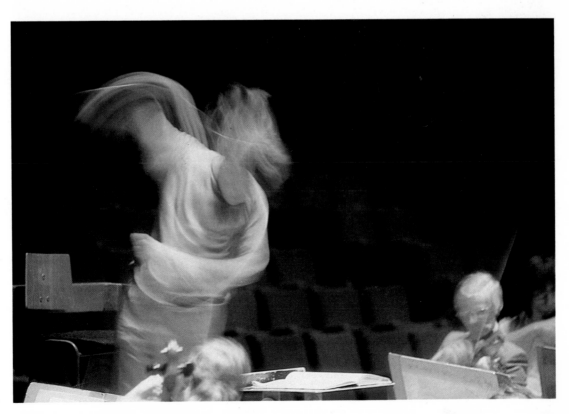

the less apparent is its speed, and the direction the subject is moving in relation to the camera determines the effect.

A subject moving parallel to the camera appears faster than if it were moving at an angle. Something moving directly towards the camera will appear slower. One must just go by general guidelines and experiment around them.

To freeze movement when the subject is parallel to the camera the shutter speed should be adjusted, for example to 1/250sec for someone walking, to 1/500sec for a runner, to 1/1000sec for a car at 30mph and to 1/5000sec for a racing car or motor bike at 150mph. The shutter speed can be decreased by one-third to photograph these subjects coming from an angle, and by two-thirds to photograph head on.

If the necessary shutter speed is too fast for the type of film or camera being used, then panning with the subject should be attempted. Panning can reduce the effective speed of the subject, for example a shutter speed of 1/125sec when panning will freeze a racing car.

Panning is moving the camera in unison with the subject. Knowing when to release the shutter only comes with practice. The right instant must be anticipated because it takes an appreciable time for one's muscles to respond to the brain's signal. The camera must be held firmly and one should move only from the waist up. It is best to pre-focus on the spot where the action will occur. If this is impossible, choose a small aperture to give a greater depth of field. The subject should be framed in the viewfinder while it is still some distance away, then followed smoothly, the shutter released and, for smoothness sake, the pan continued. Panning can be simulated by going at the same speed alongside the moving subject, eg when photographing moving cars, motor bikes, cyclists, horses etc from a car window.

Movement for effect generally does not depend on freezing the subject. A certain amount of blur is desirable. The blur can be minimal or total, whichever is most suitable for the subject. Shutter speeds under 1/125sec will blur moving subjects but, obviously, the slower the subject is moving the slower the shutter speed necessary to blur the movement.

It is recommended that a tripod be used for shutter speeds under 1/60sec but this depends on how steadily the camera can be held by hand.

In order to lose moving subjects completely and have an unobstructed view of, say, architecture, extremely long shutter speeds should be used, for example 4sec or longer. To attain such speeds, it may be necessary to use a neutral density filter,

which absorbs all wavelengths equally and thus reduces the amount of light falling on the film. A neutral density filter with a large filter factor may be necessary with a normal speed film to eliminate passersby and moving cars from the scene.

In the early days of photography when long exposures were inevitable busy streets appeared virtually empty.

The ballet dancer photograph was taken at Covent Garden Opera House on tungsten transparency film. The stage set and dancers alike were almost colourless. A pale blue filter helped to add more blue to the scene and to emphasize the pale faces of the dancers. A shutter speed of 1/60sec blurred some of the movement.

The male lead dancer is dancing while the rest of the dancers look on. A faster shutter speed would have lost the sense of movement; the dancer would have seemed posed and lifeless.

For the conductor, however, an even slower shutter speed of 1/30sec was chosen because his gestures were so frantic. The photograph is a nearly total blur but still completely recognisable. The picture was taken on a crescendo during a rehearsal of the Planets by Holst.

Textured Still Life

To give this still life photograph a soft, summery and romantic feel rather than the straightforward appearance of a colour print or transparency, black and white film was chosen, printed through a texture negative, sepia toned and hand tinted.

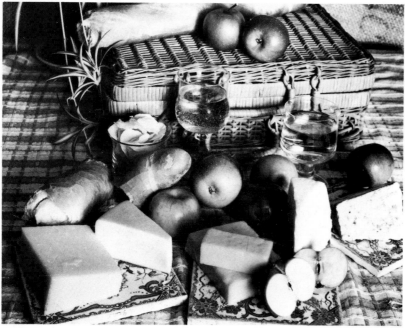

Textured still life.
A textured surface (*above*) and still life black and white photograph (*left*) were printed together, sepia toned and hand tinted (*opposite*). *Karen Norquay.*

Hand tinting offers complete control over the colour and feel of the final print but is a trickier business than is often implied: it calls for manual dexterity as much as for taste!

The still life was shot in the studio with a 5×4in format camera and a 135mm lens. To give texture, a piece of hessian was used as a background. One by one the individual items were placed on this and their relative positions carefully checked by looking through the back of the camera.

The only lighting was a large diffused tungsten light angled overhead but a piece of white card between the base of the camera and the table top reflected light into the shadows.

The depth of field (how much was in focus) was checked at various apertures and a look out kept for any odd reflections. A light meter reading was taken and the exposure of f22 at ½sec chosen for the 5×4in medium speed film.

The film was exposed and processed normally in a deep tank of fine grain developer.

A flat piece of muslin was used to make the textured screen. Regular patterns are ideal for textured screens but patterns which overpower the image are best avoided. Once made, these screens can be used again and again. They can also be bought commercially.

The muslin was photographed with a 5×4in format camera. The negative was underexposed by three stops on a slow film and then underdeveloped by 30% in a fine grain developer to give a light ('ghost' or 'thin') negative.

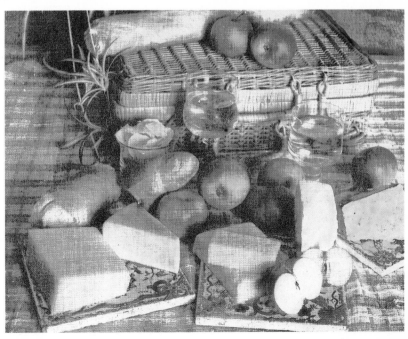

The still life negative was sandwiched, emulsion to emulsion, with the textured screen negative in a glass negative carrier which kept them in complete contact.

The sandwiched negatives were enlarged and printed onto semi-mat grade 2 bromide paper. A lightish print was prepared as a warm sepia-toned effect was the objective. (When sepia toned, too many dark tones appear cold and are difficult to hand tint.)

Once thoroughly fixed and washed, the print was sepia toned (see p. 149).

To hand tint with photo-dyes, the print must be damp so that the dyes can be absorbed by the gelatine of the paper. Water, a palette for mixing, cotton balls, brushes and blotting paper are all needed. A spare print should be used to test the colour density before attempting to colour the actual print.

After the sepia toning the print was throughly washed and stretched on a board. While damp, the large areas were worked on with a small piece of cotton wool soaked in the desired colour; the remaining smaller areas were tackled next with a soft brush. Strong colour was built up by layers of the paler colour.

Table-top Photography

Table-top photography usually means a method of taking photographs that requires very little space to operate in and a minimum of props and lighting. The results can be intriguing and quite sophisticated.

The idea behind the first image reproduced here was to illustrate a single sequence from the story/film 'Wages of Fear'.

One of the characters in the story is crushed beneath the wheel of a heavy truck and the action takes place in a pool of mud and oil. The figure, truck wheel arrangement and overall colour in the photograph are purely symbolic of the actual event.

In its original form, the figure was a 7in high plastic model of a cowboy. His hat was trimmed away from his head and the base cut from around his feet. The figure was then sprayed glossy brown. The wheel was from a toy truck and the muddy oil was a mixture of custard, indian ink, cooking oil and petrol. These artefacts were all contained within a dish approximately 15×12×2in.

The lighting was provided by one overhead 250W photoflood bulb. The film used was 35mm daylight-type colour

negative film. No colour conversion filter was used and consequently the colour print took on an overall orange cast. This was more or less intentional in order to obtain the unusual colour quality. The second example was used to illustrate the dust-jacket of a book on tales of the supernatural and other mysterious visual phenomena. The objects were one glass eye and a few free-standing translucent perspex shapes. The hollow-blown glass eye was glued to a piece of black card and the perspex shapes arranged around and in front of the eye. It was necessary to use a single-lens reflex type camera or a plate camera for this shot as the eye had to be viewed without any 'cut-off' from the perspex shapes which may have resulted from a slightly different viewpoint to that of the camera.

The photograph was taken from very close range and this enabled the perspex shapes to appear totally diffused and out of focus, giving the spectral appearance which was required.

The 'set-up' was cross-lit by a projector without a slide but with a pale green filter substitute. Colour reversal film (daylight type) was used with a blue conversion filter.

Exposure assessment in this sort of photography can be a little tricky so it is always advisable to make several alternative exposures.

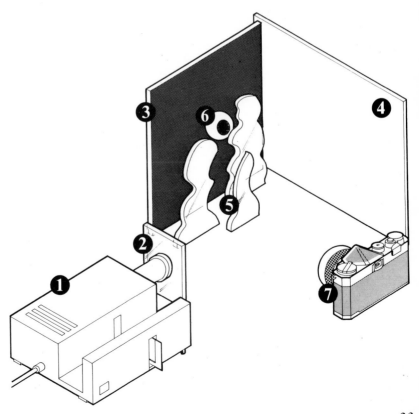

Table-top photography. Arrangement of object, lighting and camera for lower illustration on p. 24. 1, projector; 2, filter; 3, black background; 4, white reflector; 5, perspex shapes; 6, eyeball.

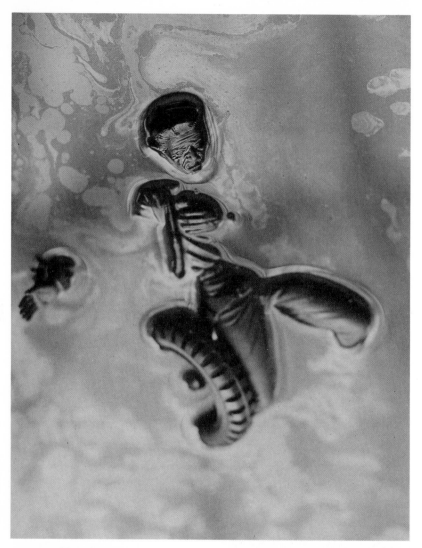

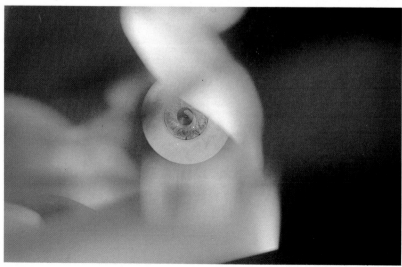

Table-top photography.
Above: an illustration depicting a sequence from 'The Wages of Fear'. *Carl Bernard.*
Left: an illustration for a book of supernatural tales. (See diagram, p. 23.) *Carl Bernard.*

Close-up Photography

When the subject is too near the camera to be brought into focus by a normal lens then either close-up lenses, extension tubes, a bellows attachment or a macro lens has to be used. Choosing which depends on the subject matter, the degree of magnification wanted and the type of camera.

A standard lens on a 35mm single lens reflex camera focuses on a subject as near as 20in but a macro lens can focus on nearer subjects to give superior close-ups.

Extension tubes are another aid here. These tubes, usually bought in a set of three, are of different lengths and can be used either singly or in combination. They fit between camera body and lens. The longer the extension, the larger the subject will appear in the frame. Like the macro lens, the depth of focus given by extension tubes is limited and they are more cumbersome to use.

A bellows attachment can be fitted between lens and camera body. It gives greater magnification, especially when combined with a macro lens, than does a macro lens alone or extension tubes. Close-up positive lens attachments are fitted on the front of the camera lens and, like extension tubes, can be combined for greater magnification. These are particularly useful if the camera has a fixed lens.

All these devices pose difficulties for the photographer. When focusing on a close subject, both depth of field and lighting are limited. To combat this, a small aperture and a slow shutter speed are almost always a necessity and the camera should be mounted on a rigid tripod.

Close-up photography. A macro lens (as used here) permits focusing on subjects close to the camera. *Karen Norquay.*

Double Exposure

Double exposure is the accidental or intentional result of two or more exposures being made on one area of film. If the camera incorporates a double exposure prevention system, an override or alternative method must be used for intentional double exposures.

To make the print shown here, the children were photographed against a black background with a 35mm camera. At this stage it was important to leave a reasonable amount of space around the children. Twenty exposures were made. The exposed film was then carefully re-wound into the cassette. This is done quite simply. Hold the camera back close to one ear and re-wind. Listen for the film to flick away from the take-up spool and cease winding immediately. When the

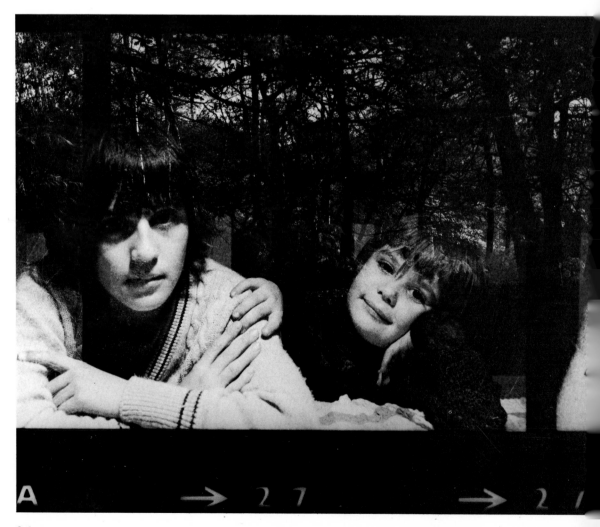

camera is opened there will be 3 or 4in of leader film protruding from the cassette. The film is then re-connected to the take-up spool and the camera prepared for running the once-exposed film through a second time.

The second series of 20 exposures was of groups of trees. The virtually unexposed areas of film (corresponding to the black backgrounds of the first pictures taken) were sensitive to the tree images. This method of double exposure meant that the combination of children and tree image was fairly arbitrary in terms of registration, but from the complete series of multiple exposures it was possible to select a satisfactory arrangement from which the finished print was made. This technique requires careful monitoring of exposure and film development; an increase in either can produce a dense negative which is difficult to print.

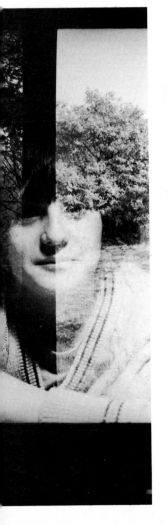

Double Exposure
Image formed by first series of exposures: children against black background.

Image formed by second series of exposures: trees with dark foreground.

The final image on the doubly exposed negative: children in foreground, trees in background.

Photograph by Carl Bernard.

Colour Filters

The general purpose of colour filters is to change the colour of the light reaching the photographic emulsion. Filters may be necessary for two reasons.

1. A natural rendition of colour can only be successfully recorded if both the film and the lighting are compatible. There are many permutations; for example the light source may be photoflood lamps, daylight or electronic flash and the film may be balanced for daylight or artificial light. To achieve a natural colour rendition the colour of the light must be corrected to conform to that for which the film is balanced. This means using colour filters.

2. Standard lighting conditions do not always convey satisfactory colour qualities. More unusual or interesting effects can be obtained with the aid of filters to create visual effects of subtle or dramatic colour.

A filter such as a colour separation filter or one with strong 'colour' will, when used in conjunction with colour film, effectively make the imagery appear all red, blue, green or whatever the colour of the filter used. Alternatively, a colour conversion filter can be used to create only a colour cast, with most of the original colour remaining virtually unaffected.

The portrait reproduced here was photographed on 35mm daylight colour reversal film with a red filter attached to the lens. The camera had a built-in, through-the-lens light meter which automatically compensated for the necessary exposure increase. The exposure was for $\frac{1}{4}$sec at f1.8. The camera was hand held. The intention was to record two or three images on one frame of film and for the portrait to have a romantic and dream-like quality. One exposure was made at the recommended setting and the film rewind button on the camera depressed. The film was then wound on keeping the film rewind button depressed. This procedure meant that the shutter mechanism was activated but the film remained stationary.

A second exposure was then made from a slightly different position and angle. Once again the film rewind button was depressed and the film transport lever activated. A third and final exposure was then made and the film wound on in the normal way. A dark background was selected for the photograph to provide areas where multiple imagery would be most effective (see p. 98).

A great many exposures may need to be made before a satisfactory result is achieved.

Colour filters.
A triple exposure using a red filter for each image. To reset the shutter without moving the film, the rewind button was depressed while the transport lever was moved. The image was built up as shown in the diagram. *Carl Bernard.*

Fisheye Lens

The wider the angle of view offered by a lens, the more complicated and expensive it becomes to correct the optical aberrations, particularly the curvature of lines. The shortest corrected wide angle lens for a 35mm camera is about 15mm focal length. It would be pointless to try to counter distortion of lenses with an angular field exceeding 100° as the optics are so unlike the normal concept of human vision that the usual rules no longer apply.

A fisheye lens is made up of 10 or more glass surfaces, the front ones having extreme diameters. The relative weight of the lens, the difficulty of attaching filters to such wide diameters and the chance of the photographer's hands and/or feet getting into the picture hamper its use. Depth of field extends from infinity to within about 3 or 4in and, as most of these lenses have a working aperture of *f*8, no focusing is necessary. The widest angle fisheye lens forms a completely circular image

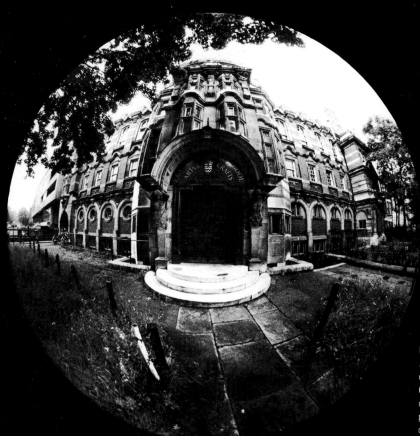

Fisheye lens.
Left and opposite: the distortion produced by a 6mm lens on 35mm camera is most pronounced at the edges of the picture. *Karen Norquay.*

within the 35mm negative format while others, not quite as wide, fill the frame right to the edges. Small interiors look vast, lines (except for radials) are markedly curved and there is, in fact, overall distortion especially around the edges.

Fisheye lenses have special uses, such as total sky photography for meteorological purposes, but the use of them otherwise, except for bizarre images, is definitely limited. If employed too often the distortion becomes monotonous and boring. The effect of the fisheye lens overwhelms the final image and there is a need for careful selection of subject matter. Some fisheye lenses on the market offer inferior definition and a thorough test should be made before buying. As they are of limited application, hire of the more expensive type of fisheye lens should be considered.

The photograph illustrated below was taken in a relatively small greenhouse to give a jungle like atmosphere. The 35mm camera was on a tripod to counteract any camera shake caused by the weighty fisheye lens.

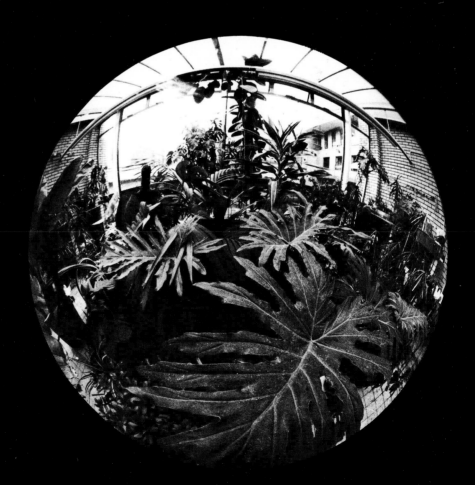

Telephoto Lens

A telephoto lens is a long focus lens which provides a larger image in the viewfinder than that of a standard lens without the photographer having to move nearer to the subject. Two lens units are the key to how a telephoto lens is constructed. These units are separated from each other by varying lengths; the amount of separation determines the focal length of the lens.

The positive components in the front unit create converging rays of light and the negative components in the second unit widen them out again. A long focus lens does not have these components; it therefore needs to be much longer and have a larger focusing bellows extension than a telephoto.

The telephoto lens of today is based on the two lens unit construction but they are extremely complex, each unit requiring many components to correct their individual aberrations. A telephoto lens has a narrower angle of view than a standard lens and, when set on the same aperture, a shallower depth of field. There is also much more likelihood of camera shake with such lenses. The longer and therefore the heavier the lens, the faster the shutter speed needed for hand-held shots: the minimum speed for a 135mm lens is 1/125sec, for 200mm lens 1/250sec and so on.

The effect of a telephoto lens when seen through the viewfinder of the camera is like looking through a telescope. It is of great use when there is no way of getting close to the subject, for example when photographing animals.

Telephoto lenses are very popular in sports photography although, because of the foreshortening effect, players tend to look as though they are on top of each other. In cricket the batsman appears to be immediately in front of the crowd but, because of the shallow depth of field, he will still stand out from the out-of-focus crowd. If several people are photographed with a telephoto lens to fill the frame, the compression of perspective will give the effect of a large crowd.

A telephoto lens was used to exploit the short depth of field in the photograph of the girl. Only the girl is in focus and stands out against the blurred fencing.

Telephoto lens.
Comparison of the images from a standard lens (main picture) and 135mm telephoto lens (inset).
Karen Norquay.

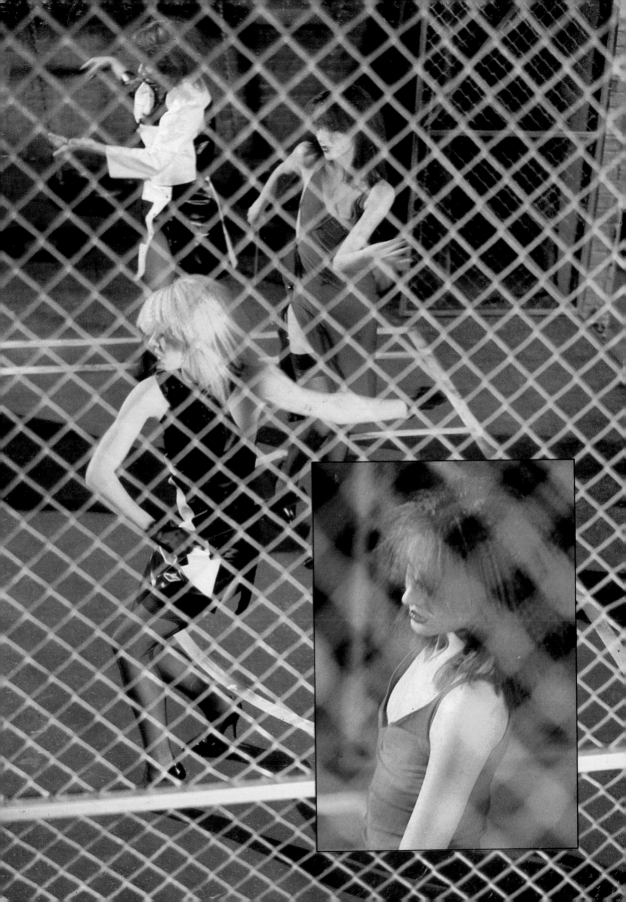

Zoom Lens

Most lenses have a fixed focal length. A wide angle lens has a short focal length which records the subject as a small image, while a telephoto lens with a long focal length records a large image of the subject. The focal length of a lens is indicated on the lens itself in millimetres.

A zoom lens, however, has a variable focal length and thus the image size can be enlarged or reduced.

Like the telephoto lens (see p. 32) the zoom lens is made up of two elements, one positive and one negative. The distance between these two elements determines the focal length and can be altered. The most common ranges of focal length are 40 to 120mm and 80 to 200mm.

This popular, but expensive, accessory can replace a series of fixed focal length lenses. Such a versatile device has obvious advantages in sports or any kind of action photography where there is a need to quickly 'zoom in' on the subject. Perhaps less obvious though are the unusual effects that can be achieved by changing the focal length of the lens during an exposure.

To change the focal length while the shutter is open, a shutter speed of $^1\!/_8$sec or longer is necessary. To obtain such speeds in normal lighting conditions for the photograph illustrated, a slow film and small aperture were chosen. At these slow shutter speeds, a rigid tripod is necessary to prevent camera shake.

The sprinter was posed and focused in the middle of the picture. He then had to freeze the movement while the $^1\!/_4$sec exposure was taken. As it is easier to 'zoom out' than 'zoom in', the image of the sprinter was therefore made as large as possible in the frame and then reduced by zooming out.

To accentuate the zoom effect, the photograph was printed in the darkroom several times, each time on a smaller scale and the prints then mounted one on top of the other.

Other interesting effects can be created by panning (see p. 18) and zooming simultaneously. In other situations, shutter speeds of 1/15 or 1/30sec can be used.

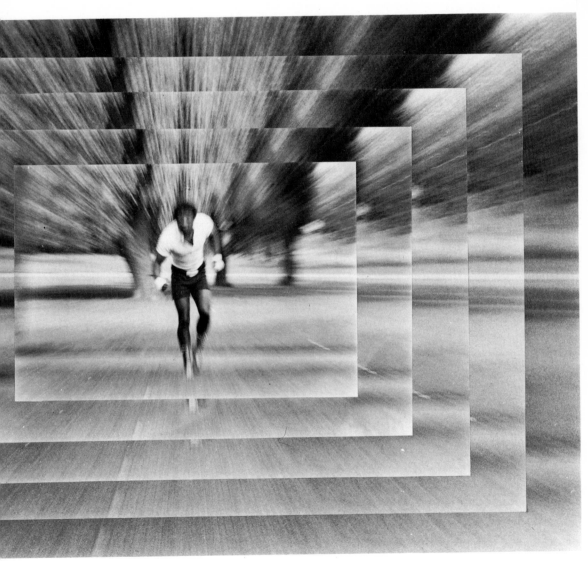

Zoom lens.
The focal length of the 80–200mm zoom lens was decreased during the ¼sec exposure – zooming out. Several prints of progressively smaller size were then mounted on top of one another. *Karen Norquay*.

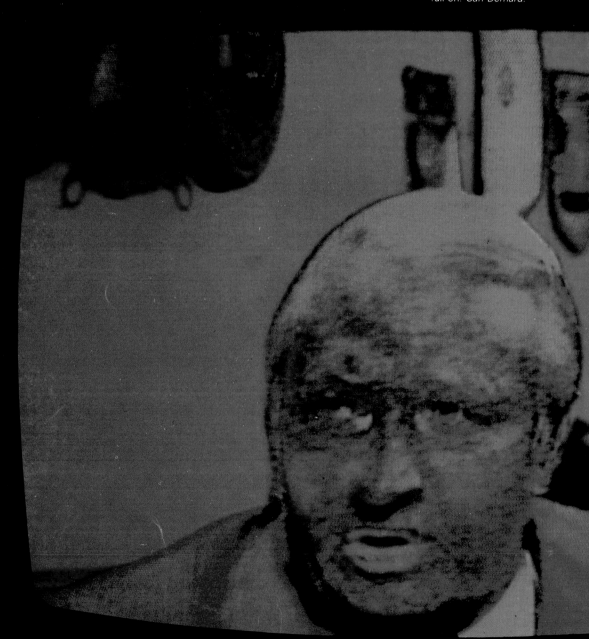

TV image.
This photograph was taken using artificial light colour negative film and with the colour and contrast controls of the TV full on. *Carl Bernard.*

TV Image

With a camera and a tripod, it is a simple matter to record images from the television screen either in black and white or in colour. Exposure times of less than 1/25sec are unsatisfactory, however, because of the time required for the signal to scan the lines of a TV screen. Such exposures will, therefore, only record part of the overall screen image. Because of this relatively long shutter speed, it is only possible to record fairly inanimate subjects from a TV screen, although interesting abstract shapes can result from the shorter speeds.

With a black and white picture, you are restricted to a contrast control only, but with many colour sets there is a wide range of permutations, ranging from very subtle to livid and intense colour.

The image reproduced here was photographed from the television set with the colour and contrast controls set at maximum. The film used was artificial light colour negative film and the exposure was 1/15sec at *f*8. The print was made without any specific filtration as the colour was always intended to be totally unbalanced.

The black and white photographs (p. 38) taken from the TV were taken with panchromatic black and white roll film with exposures of 1/8sec at *f*8. The negatives were contact printed onto a sheet of 10×8in high contrast bromide paper. The print was then photocopied onto 5×4in ordinary film. An enlargement was made from the 5×4in negative onto a 12×15in sheet of Autone.

Autone is an orthochromatic (blue and green sensitive) printing paper which can only be used under red safelights. It is available in a range of colours, including silver and gold.

TV image.
Twelve images from a
black and white TV printed
on silver Autone printing
paper so that the areas
reproduced here as pale
grey were silver. *Carl
Bernard.*

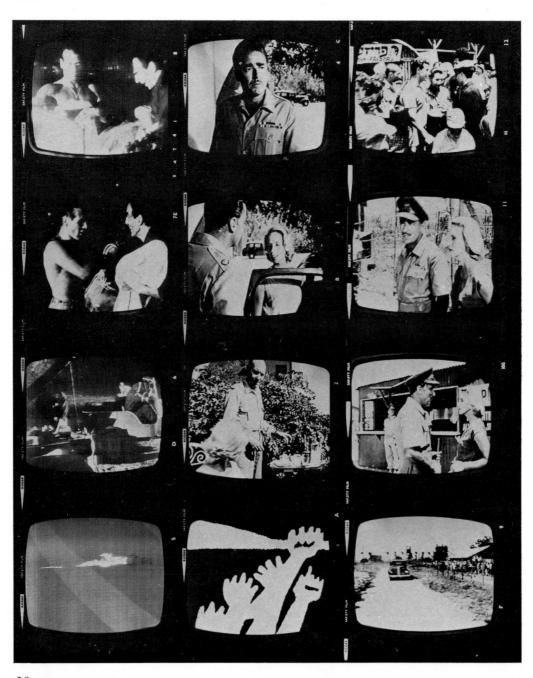

Polarisation

If light is considered as a wave vibration, the vibrations occur in all directions and at right angles to the direction in which the light travels. Under certain conditions, however, light will vibrate in one plane only, ie the polarisation plane. Such light is referred to as polarised and can be controlled by special polarising filters. The phenomenon of polarisation cannot be adequately described within the context of this book. A more detailed analysis than that given below and its application to crystal optics would be of excessive length and of somewhat restricted interest.

The main uses of polarising filters are:

1. To reduce reflections from glass or polished surfaces and to control the reflections from water surfaces (the effect most noticeable when wearing polarised sunglasses).

2. To increase colour saturation which might otherwise be reduced by reflections. The elimination of unnecessary reflections and increased colour saturation will improve picture quality. A perfect polarising filter will show no appreciable colour bias. In theory, a polarising filter will affect exposure by a factor of two but, in practice, this is nearer four although it does vary from filter to filter.

There is another aspect of polarising material which is used in scientific analysis and which provides a visual effect unlike any other. If a crystalline material or synthetic film such as Cellophane is placed between two polarising filters, certain polarisation colour changes become visible if one of the two filters is rotated. These colours can be very beautiful and have often been photographically recorded for use in numerous advertising projects. The usual method employed in photographing these images is with a camera attached directly to a microscope but this is a sophisticated technique and custom-built apparatus specifically designed for microscopy work is not readily available. There are alternative ways, however, of recording this intriguing and magical colour effect. The most simple is to take a close-up photograph which was the technique used to obtain the transparency reproduced on p. 41.

A crystal of sodium thiosulphate was sandwiched between two polarising filters and placed on a light-box. The top filter was rotated to the point where the light perceived within the crystal structure was at its most intense and brilliant. The area surrounding the filters was masked out with a piece of black

Polarisation.
Unpolarised light vibrates in all directions perpendicular to its axis of travel: polarised light vibrates in one direction only.

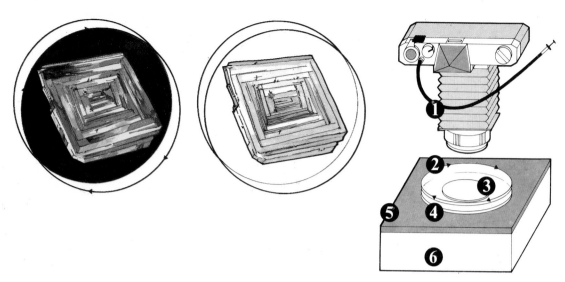

card from which a circular hole had been cut. This reduced all extraneous and distracting light from around the immediate area to be photographed. Using a very substantial tripod, a 35mm single lens reflex camera with extension bellows attached was positioned at a point directly above the polarised crystal. When using bellows at maximum extension, depth of field is virtually non-existent and very great care has to be taken with focusing. It is impossible to undertake this sort of close-up work without a totally dependable, firm and stable tripod. The enormous exposure increase incurred with maximum extension also requires total stability from the tripod during exposure.

A very high speed daylight type colour reversal film and a filter to compensate for the artificial light were used.

Polarisation.
A crystal of sodium thiosulphate was sandwiched between two polarising filters. One filter was turned until the transmitted light was most brilliant and the arrangement photographed. 1, camera with bellows; 2, top polarising filter; 3, crystal; 4, bottom polarising filter; 5, card; 6, light-box.

Projector Image

A projector image is one which is achieved not by conventional methods of photographing an original object by reflected light but by photographing the illuminated image of a projected colour transparency.

The image reproduced here originated from a sharp, bright and very colourful 35mm transparency. The actual subject matter was immaterial in view of the subsequent optical distortions and recording method.

The transparency was projected directly into the lens of a 35mm single lens reflex camera which was loaded with colour reversal film type B (for artificial light). A piece of hammered glass was interposed between the projector lens and camera lens and the exposure was calculated with the built-in meter.

Polarisation.
Right: a sodium thiosulphate crystal between two polarising filters recorded on daylight transparency film using a compensating filter (see diagram opposite). *Carl Bernard.*

Projector image.
Below: a 35mm transparency projected directly into the camera lens through a piece of hammered glass. *Carl Bernard.*

Focusing and image formation were achieved by permutations of camera and projector focusing, distance between camera and projector, and by varying the distance between the hammered glass and camera lens. The most interesting images appeared when the camera and projector were approximately 3ft apart but the variations are limitless, depending on scale, desired image and type of glass used for the intermediate distortion. The single lens reflex camera was essential to view the exact qualities of image being photographed.

The intensity of light from the projector can cause problems with exposure and it is advisable, as in all cases of difficult exposure assessment, to back up the estimated light reading with a series of alternative exposures (bracketing). This particular arrangement of image and light source would have been very easy to overexpose as the meter was acutely sensitive to the most brilliant areas of the projected transparency.

Back Projection

Back projection is a method of producing an image on a screen which can be photographed directly or used when a subject requires an unusual background or when the separate elements are difficult or impossible to combine. The size of projected image and screen are obviously determined by the size of the main subject. The correlation of lighting levels between the back-projected image and the foreground subject must be carefully balanced to ensure a satisfactory result.

The print reproduced on page 44 was achieved by photographing the image of a projected transparency on a specially prepared screen. The transparency was made by applying coloured inks to two pieces of transparent acetate the same size as a frame from a strip of 35mm film (ie 35 × 38mm). While still wet, the two inked surfaces were then sandwiched together between two pieces of glass from a slide mount and the mount was re-assembled for projection.

The screen upon which the transparency was then projected was a sheet of tracing paper taped across the flat surface of a sheet of reeded glass.

A 2¼in square format single-lens reflex camera was loaded with colour reversal film type B (artificial light). It was then positioned with the lens pointing directly towards the projector lens and focused upon the back-projected image, which was

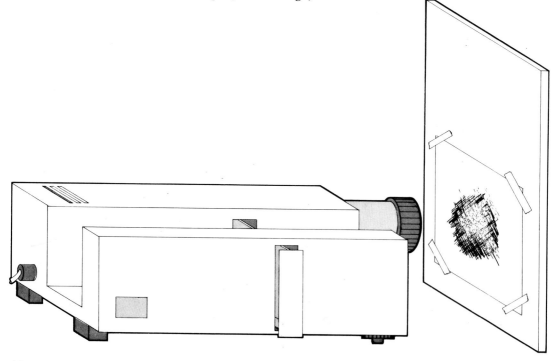

approximately mid-way between the two (see diagram).

The exposure was assessed by holding a meter up against the camera side of the back-projected image. The reading was taken without the incident light attachment. The flare which surrounds the central image was obtained by holding a rolled sheet of clear acetate around the lens mount of the camera and pointing towards the projected image during exposure. The reeded glass and transparency were used with the special intention of an image for the front of this book. Transparencies of any kind, however, are suitable for this method of image recording. It is simply a matter of personal choice as to the separate elements and composition used.

The production of hand-made transparencies to provide abstract and brilliantly coloured images is simply a matter of applying colour with fibre-tip pens, brushes or whatever to pieces of translucent material and making them up as projection slides. If black and white negative material is used for projection and re-photographed on black and white film, the results will be positive and consequently re-project as such.

It is not within the scope of this, or any other, book to cover all permutations, experimental processes or image making ploys that are available by back projection or slide making. With the basics of the projector, slides, screen and camera, the end results depend on not a lot more than being able to assess the correct exposure.

Back projection.
Arrangement of projector, screen of tracing paper on reeded glass, and camera for the photograph on p. 44. The camera lens is surrounded by a rolled sheet of clear acetate.

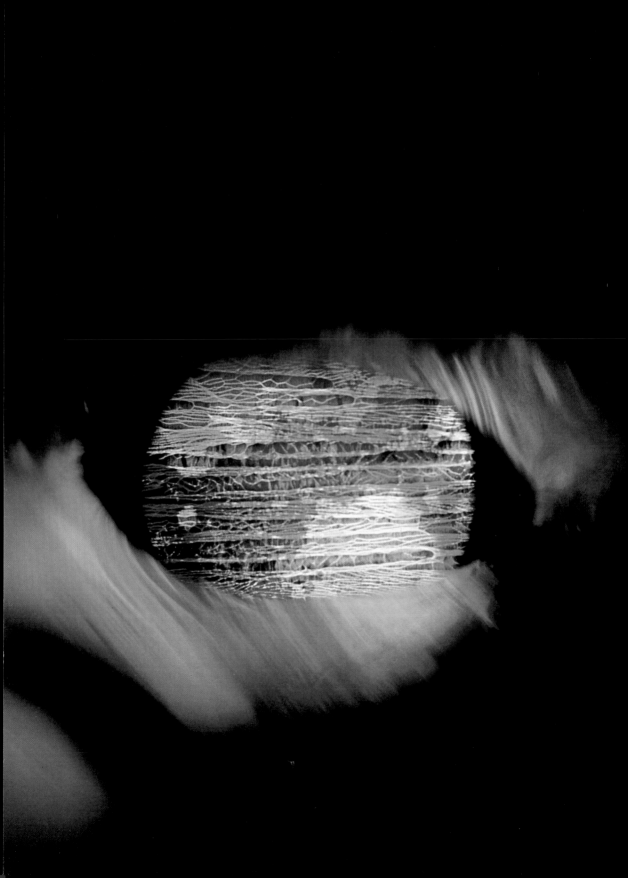

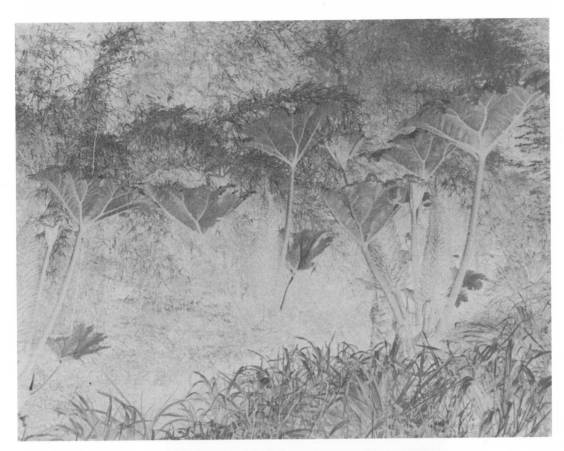

Reverse colour printing.
Above: a colour negative photographed against available light with daylight colour negative film (see p. 46). *Carl Bernard.*

Back projection.
Left: photograph of inks sandwiched in a slide mount and projected onto a screen of tracing paper and reeded glass. *Carl Bernard.*

Cibachrome in the camera.
Right: Cibachrome used in the camera in the same way as negative materials and exposed for 60sec at *f*16 (see p. 47). *Karen Norquay.*

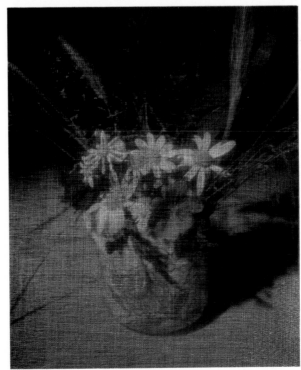

Reverse Colour Printing

A reverse colour print is one which is a reproduction of the negative as a positive colour print. The colour perceived in a colour negative can, according to the subject matter, be more visually interesting than the positive print.

The print, reproduced on p. 45, of an interesting plant form originated from a $2\frac{1}{4}$in square colour negative. The negative was taped flat against a sheet of glass and photographed against available daylight. The camera used was a 35mm single lens reflex type with an extension ring fitted to enable focusing on the very close image. The film stock was daylight type colour negative film with an ASA rating of 100.

An exposure meter was held very close to the negative and the reading taken through the negative and against the light. The exposure of 1/125sec at f8 was made possible by the very bright daylight and included the allowance required by the addition of the extension ring. The exposure meant that the camera could be hand held but great care was taken because of critical focusing.

Three exposures were made, one at the above setting, one at a full stop above this and one a full stop below. This allowed for any discrepancy in the initial exposure assessment.

When the colour film had been developed, a print was made from the most suitable of the three negatives. The only criterion for the colour print in terms of printing was exposure. Any correction of colour balance and filtration was unnecessary because of the 'unreal' visual quality that was required.

As an alternative to the colour print, a colour transparency could have been made for projection. In this case colour reversal film would have been used instead of colour negative film.

Reverse colour printing.
1 Sun used as light source.
2 Negative taped on glass.
3 Camera

Cibachrome in the Camera

Cibachrome paper is very similar to colour reversal film and there is no reason why Cibachrome paper should not be used directly in the camera. There are, however, limitations:

1. The print cannot be enlarged.
2. The speed of the paper is approximately ASA1. Thus only still objects can be safely photographed although a very powerful electronic flash would solve the exposure problem.
3. The paper is colour balanced for printing with an enlarger. The paper may be correct for tungsten lights but filters would have to be used in daylight and with flash.
4. There is a lateral reversal of the photograph although a reversing mirror attached to the lens could be used to produce a correct image.

A small still life print with a soft focus textured effect was desired and Cibachrome paper used directly in the back of a 5×4in format camera seemed ideal.

The still life was lit by an overhead spotlight positioned to one side of the camera. A piece of white card reflected more light into the shadow areas. Harsh bright lighting was necessary as the speed of the paper was so slow; with soft focus plus a textured negative, the result might have been amorphous if gentler lighting had been used!

In total darkness, a 5×4in sheet of Cibachrome paper plus a 5×4in texture negative of muslin (see p. 20) was slotted into a dark slide. A light meter reading was taken using ASA1 as a guideline. It was decided to test a wide range of exposures. The aperture was set at $f16$ and the depth of field was checked. A piece of fine stocking was stretched over the lens to give a soft focus effect.

The dark slide was slotted into the back of the camera and the paper given four different exposures of 40, 60, 80 and 100sec. This was achieved by giving the whole of the paper 40sec exposure and then moving the dark slide over the exposed paper at 20sec intervals. The test sheet was processed normally. The 60sec exposure was found to give the best result.

The final print (p. 45) was set up in the same way, shot at $f16$ at 60sec and processed normally.

2
Films and Processing

Introduction

The almost limitless permutations of exposure technique, film stock and development procedures provide the enthusiast with a constant source of photo-reproduction methods. Once a basic understanding of the principles of image formation upon light-sensitive materials is understood, films and processes can be experimented with to obtain unusual and stimulating images.

In this type of work many attempts are usually necessary before one is entirely satisfied. Whenever possible, start with correctly exposed and developed negatives or prints before transferring images to alternative film or paper stock. The integrity of the original is consequently preserved, and one can try again if the result is unsatisfactory.

There are many effects that can be achieved by experiment or accident. For example, the Sabattier effect was discovered in 1862; the French photographer who gave his name to it couldn't have foreseen the effect, but it has been in the repertoire of photographic techniques ever since.

Nearly all the black and white techniques illustrated in this book were achieved with small-format panchromatic films and cut sheet films such as blue-green sensitive lith or Autoscreen. Most of these materials are available from leading photographic retailers, but Autoscreen film is a specialist film usually only available direct from the manufacturer (Kodak). There are alternative ways, however, of creating a screening effect, by using either a specially made half-tone screen (magenta screen), which comes in various dot sizes, or dry-transfer films such as Letratone. This will not give a true half-tone breakdown, but an impression of one. Dry-transfer material can in fact be used to create numerous tone and texture effects when combined with negative material during printing.

Generally speaking, ordinary blue-green sensitive film is used for straightforward copying from black and white continuous-tone prints or film, irrespective of whether one wishes to experiment on the emulsion with inks or to obtain a Sabattier effect. The same applies to lith films, but the resulting negative or positive image loses practically all intermediate tones and, if fully developed, appears as black and white, ie highlights as black and shadows as clear areas. Ordinary copy films are relatively fine-grained and should not cause any appreciable grain exaggeration.

C. B.

Infra-red

Infra-red colour.
Previous spread: tropical
foliage recorded on
100ASA infra-red colour
film. No filter was used.
Karen Norquay.

Visible light makes up only a small part of the whole electromagnetic spectrum and its colour is determined by its wavelength.

Violet is the shortest wavelength of the visible light spectrum and red the longest. Infra-red wavelengths are even longer than red and are invisible to the human eye. However, they give off heat/energy and film can record this. Infra-red film is treated with dyes which are sensitive to these heat waves. The film can be used in almost total darkness and this is particularly advantageous when, for example, animals are to be photographed at night. It is also of great use in medicine, where it can detect disorders not visible on normal films. In aerial photography it is used to penetrate haze. Infra-red film also offers exciting and unusual opportunities to amateur and professional photographers.

Black and White

Special precautions must be taken in the use of black and white infra-red film. It is particularly sensitive and must be loaded into the camera and unloaded in complete darkness.

As infra-red wavelengths are much longer than visible wavelengths the plane of focus is different. No matter how good the lens, adjustments are necessary and as a rule these are indicated on the focusing ring by a red dot. The camera should be focused normally and then the focusing ring moved round to be opposite the red dot.

In outdoor photography a filter that eliminates every wavelength but that of infra-red should be used.

Green foliage reflects powerfully in the infra-red part of the spectrum, so much so that infra-red film was used for the detection of camouflage in the Second World War, since the paint used at that time did not reflect infra-red. Landscapes assume a snowy appearance on infra-red film, foliage appears white and fluffy and blue skies appear black.

The 'impressionistic' picture (p. 52) was taken on infra-red black and white film using an infra-red transmitting filter over a standard lens on a 35mm camera. As there had to be a change of focus and a fairly dense filter was being used a small aperture (*f*22) was chosen to ensure sharpness.

The film was processed according to the manufacturer's recommendations in a universal type developer.

A very soft light print was made on bromide paper. A very fine piece of gauze over the enlarger lens gave the print a soft

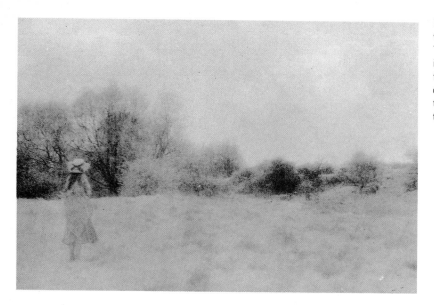

Infra-red black and
white.
The normal contrast of
infra-red black and white
films was reduced by
diffusing the light from
the enlarger and sepia-
toning. *Karen Norquay*.

focus effect (see p. 89). Once thoroughly fixed and washed the
print was sepia toned (see p. 149). If the negative had been
printed normally, the final picture would have been fairly
contrasty.

Colour

Unlike infra-red black and white film, infra-red transparency
film can be handled in daylight. Its emulsion layers are sensitive
to blue, green and infra-red wavelengths.

Extraordinary colours can be achieved from normal set ups.
Landscape takes on a particularly odd appearance: the sky is
relatively normal but the foliage comes out as magenta or even
red. Skin has a greenish cast and lips are yellow.

The manufacturer recommends using a yellow filter but, as
factual colours are of no consequence, different filters (green or
red) can be tried or one can abandon filters entirely.

Without filtration the colours are very cold; with a yellow
filter the purples are redder and there appears to be more
overall colour; with a red filter the picture is much warmer and
the whites become a definite yellow. For best colour results
bright lights or sunny days are needed but the film is very
contrasty and allows little detail in the highlights or shaded
areas.

The picture on pages 48–49 was taken in the tropics where
the foliage was very lush and full of chlorophyll, thus appearing
bright red. No filter was needed.

For a similar effect in non-tropical regions, it is best to
shoot foliage on a bright sunny day in spring with a yellow filter.

Colour Film Used For Effect

The colour composition of different types of light varies enormously. The colour of light can be expressed by its colour temperature on a scale which represents the colour quality and content of a light source. Colour temperature is calibrated in Kelvins or mireds.

Manufacturers try to balance the three emulsion layers in colour reversal film with three most common types of lighting:

1. Daylight film is suitable for daylight, electronic flash and blue flash bulbs. It is balanced between 5000 and 6000K (the blue end of the colour temperature scale).
2. Artificial light film Type A is suitable for bright short-life photofloods and is balanced for 3400K. If used with

Colour film used for effect.
Colour transparency film used as negative film.
Karen Norquay.

professional photographic lights (3200K), there will be a bluish cast.

3. Artificial light film Type B is the most common artificial light film. It is balanced to 3200K and is suitable for 500 to 1000W spotlights and floods, ie the red end of the colour temperature scale.

If none of these films is directly suitable for a particular scene and lighting arrangement then colour correction filters must be used.

The colour balance of colour negative film is not as critical as that of colour transparency film since colour casts can be corrected by filtration at the printing stage. There are, however, two types of colour negative film: type S for daylight and type L for artificial light.

Daylight is much bluer and less red than artificial light. When artificial light film is exposed to daylight, the film takes on a strong blue cast, yellows and reds are muted and whites have a blue tinge to them. If the film is underexposed, daylight can look like moonlight. A similar effect is possible by using daylight film and a blue filter.

An exaggerated colour cast can be caused by reciprocity failure. The way a colour film reacts to light alters dramatically with very long exposures. Reciprocity law failure comes into effect at shutter speeds of approximately 1sec and longer. It changes the colour balance of the three emulsion layers in colour reversal film but to what extent is unpredictable. If reciprocity failure is to be avoided then the colour correction filters recommended by the film manufacturer should be used.

Sabattier Effect

When the development of an exposed film is interrupted about half-way through the process and the film is exposed to a light source before the development is continued, parts of the original image may be reversed, black for white and white for black. The phenomenon is hardly ever controllable and, consequently, the effects achieved vary constantly. The same effect can sometimes be observed when films are developed in an unsafe light source. It is known as the Sabattier effect or pseudosolarisation.

Because the results of the Sabattier treatment are unpredictable, it is inadvisable to work with the original film from the camera and better to use prints or film positives made from the original negatives.

Sabattier effect.
Exposure of a film to light during development reverses parts of the image, ie white for black, and black for white. *Carl Bernard.*

An original continuous tone landscape photograph was photocopied onto a sheet of 5×4in lith film. The time for a standard developing procedure was 4min. To produce the Sabattier effect, however, the film was exposed to an overhead 60W light bulb at a distance of 5ft for 1sec after the first 3min of development. The film was then returned to the developer for a further 1min.

The negative was closely inspected under a red safelight during the second stage of development to ensure the Sabattier effect had occurred and to judge the exact moment to transfer negative from developer to stop bath. The film was then washed and fixed as normal. The negative was printed onto a hard grade of paper to increase the contrast and linear effect.

The combination of lith film and the Sabattier technique can produce images with a very dramatic quality and with an almost totally linear appearance.

It is possible to produce a Sabattier effect using panchromatic film stock but the time required and material expense (films cannot be observed satisfactorily during development) do not make an ideal combination for experiment.

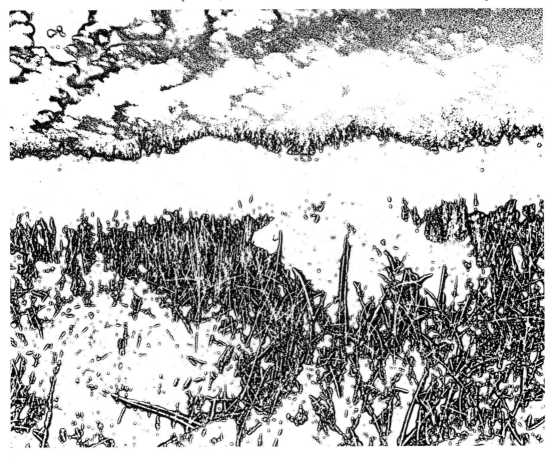

Intensification

Due to exhausted developer, the film for the prints on p. 57 and p. 58 was underdeveloped and the negatives were low in contrast and density. Prints made from these would have been flat and lifeless and a uranium intensifier was used to save them. Once intensified, the negatives were slightly grainy and contrasty. Instead of trying to combat this in the printing, it was deliberately accentuated by printing on lith paper.

When a negative is particularly important, a print should be made before any after-treatment, whether intensification or reduction, is attempted. If anything does go wrong, the print can always be rephotographed. Negatives must be thoroughly fixed and washed before any kind of intensification. Intensifiers build up density of the negative, depositing metal on the silver already present in the emulsion. The effectiveness of intensification depends entirely on the amount of detail on the original negative: an underexposed negative will have very little existing silver to intensify whereas the underdeveloped negative has points of silver which can be coated with uranium to increase the overall density.

Uranium intensifier is the easiest type to use. If things go wrong, the process can be reversed by a weak solution of sodium carbonate and, after washing, intensification can be tried again. The result of the uranium intensifying process is not completely permanent; if permanency is required, a chromium intensifier should be used.

To make uranium intensifer, the two stock solutions detailed below should be prepared separately and combined at the last moment.

Solution A	Uranium nitrate	20grains or 11g
	Water up to	20oz or 500ml
Solution B	Potassium ferricyanide	200grains or 11g
	Water up to	20oz or 500ml

To mix, take four parts of solution A and four parts of B and add one part of glacial acetic acid.

The negatives soaked in this mixture become brown and look opaque. By stopping the action early, underexposed shadow detail can be strengthened; too much intensification will increase the contrast greatly. Washing removes the yellow stain but this should be done in several baths of still water as running water will cause patching.

Chromium intensifier is more complicated but more reliable

Intensification. Sepia-toned lith print from an underdeveloped negative treated with uranium intensifier. *Karen Norquay.*

than uranium. The negative is bleached out completely in a mixture of potassium bichromate and hydrochloric acid and washed until the yellow disappears, at the same time re-exposing it to artificial light for a few minutes. It should then be re-developed in an ordinary print developer (D163 or Teknol, not a fine grain developer), washed and dried.

The bleaching solution is made up in the following way.

Solution A	Potassium bichromate	50g
	Water	1 litre
Solution B	Hydrochloric acid	100ml
	Water	1 litre

For medium intensification, add 4 parts of solution A and 1 part of solution B to 5 parts of water.
For contrast intensification, add 4 parts of solution A and 2 parts of solution B to 1 part of water.

High/Low Contrast

High contrast in a negative or print is determined and can be controlled by many factors. At the negative stage, film type, lighting conditions, subject matter and development should be considered. When a print is being made, contrast is controlled by negative quality, choice of enlarger, exposure, grade of printing paper and type of developer.

'Figures in a Snow Landscape' was a subject of natural contrasts and was recorded on 35mm medium speed panchromatic film stock. The film was developed with a 20% increase on the recommended time to give added contrast to the negative. The print was made on a high contrast paper from a condenser-type enlarger. The overdevelopment, high contrast paper and condenser enlarger were a combination of factors which contributed directly to the intentional high contrast. Another set of conditions would ensure print images of low contrast, eg underdevelopment and low contrast paper.

The young deer was photographed on a high speed panchromatic film and the meter setting was over-ridden to increase the recommended exposure by one full stop. The film was then underdeveloped by approximately 25% to compensate for the intentional overexposure. This produced a negative with a very low contrast. The image was selected from approximately

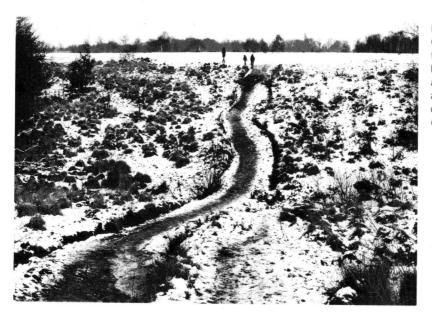

High contrast.
Overdevelopment of the film and printing onto a high contrast paper using a condenser-type enlarger accentuated the natural contrast of this subject. *Carl Bernard.*

one-third of the overall negative area in order to restore a degree of 'bite' to a print that might otherwise have appeared unintentionally flat from an underdeveloped negative. The print was made on a soft grade of paper and from a cold cathode type enlarger. This combination retained the soft almost monotone effect that was not entirely unsympathetic to the subject.

Generally speaking a high contrast black and white print can be achieved by combinations of:

1. Brightly lit (high contrast) subject.
2. Slow rated ASA film.

Low contrast.
Overexposure, underdevelopment, soft printing paper and a cold cathode type enlarger produced this low contrast print. *Carl Bernard.*

3. Maximum development.
4. Condenser type enlarger.
5. High contrast printing paper.

Prints of low contrast are usually attributed to one or more of the following:

1. Flat overall lighting.
2. Fast ASA rated film.
3. Minimum development.
4. Cold cathode enlarger.
5. Low contrast printing paper.

Like most graphic effects high or low contrast is only really effective with compatible subject matter.

Reticulation

Reticulation appears in the form of a very fine and irregular pattern across the whole negative area. It happens when a film is transferred from a warm solution to a cold one. The gelatine swells and then suddenly contracts. Reticulation can also be caused by the reverse process, ie a sudden expansion of the gelatine when the film is transferred from a cold to a warm solution. Certain intensification processes can also cause reticulation.

The nude (p. 62) was photographed on 35mm panchromatic film which was then processed in ice-cold developer. The development time was extended from the normal 10min to 20min to take into account the lower temperature. The film was immediately transferred to a very warm (70°C) stop bath and fix and, finally, washed for 20min in water at 20°C.

A 10×8in bromide print was made from the reticulated negative using a very hard grade of paper. The figure on the negative was intentionally small within the 35mm format so that the maximum amount of reticulation would be visible on the enlarged print. A high quality enlarging lens was imperative to preserve the definition of the reticulated emulsion structure. The print was rephotographed using lith film (see p. 114) to further exaggerate the definition and contrast of the reticulated structure by losing virtually all intermediate tones. The finished print was finally printed on a very hard paper.

A film that has been developed in the normal way and fixed in an acid hardener can also be reticulated. Such a negative

should be immersed in a 10% solution of sodium carbonate at 52°C (125°F), until the gelatin swells and becomes very soft. It should then be quickly transferred to an ice-cold water bath which causes the gelatin to suddenly contract.

Intentional reticulation is rarely a controllable technique. Many attempts may be necessary to achieve a satisfactory result. Different types of film can be experimented with.

Reticulation.
Reticulated negative printed onto lith paper.
Carl Bernard.

Autoscreen

Autoscreen is an unusual film in that it produces automatically a breakdown from continuous tone to a half tone screen dot. The emulsion incorporates a very fine screen of 133 lines per inch. It is used under red safelights and with lith developers.

The photographic effect of Autoscreen negatives is most

Autoscreen.
Right: a Sabattier-treated print from a lith negative, photocopied onto Autoscreen film and then given another Sabattier treatment. *Carl Bernard.*
Overleaf: a continuous tone print copied onto Autoscreen film and enlarged. *Carl Bernard.*

successful when the negative is enlarged; the fine 133 line structure will not otherwise be very apparent. It is possible to assess the screen dot size in the finished image/print by dividing 133 by the degree of enlargement from the original negative size. For example, if an original Autoscreen negative of 5×4in is to be enlarged to make a 10×8in print, the screen dot size will be increased to $66\frac{1}{2}$ (ie $133 \div 2$). If only a portion of the negative is enlarged, the screen will be proportionally much greater. The processing of Autoscreen film is rather exacting if a technically perfect rendition of a half tone is required. Highlight areas within the negative can be controlled by exposure and shadow areas by an overall secondary fogging exposure. Development differs from normal lith processing and it is advisable, therefore, to refer to the manufacturer's instructions.

A straightforward image was reproduced from a continuous tone black and white print. The 10×8in print was photocopied onto a 5×4in sheet of autoscreen film but the image only occupied an area of approximately 2×2.5in within the overall film size. The print made from this negative, therefore, reproduced a dot screen four times up on 133 at 10×8in format. For the second example a 10×8in print was made from a 5×4in lith negative that had received the 'Sabattier' treatment (see p. 54). After photocopying onto Autoscreen film, the negative of the Sabattier print was given another Sabattier treatment. In fact, the Sabattier effect was doubled and an Autoscreen introduced at each stage (see p. 63).

A great deal of mileage can be got from Autoscreen film in the pursuit of graphic effect and no two images need ever be the same. Great care should always be taken with the film stock, however, as the film surface is very sensitive. The manufacturer's sizes of 10×8in and 14×11in necessitate cutting; any slight scratch, abrasion or finger mark will record. This, in most cases, will be detrimental to the regular and geometric visual structure of the image.

Grain

Photographic emulsions consist of fine silver halide crystals or 'grain' embedded in gelatin. As larger grains generally react to light faster than smaller ones, fast film contains larger grains than slower films. Fast films are therefore usually associated with a more grainy image. Another factor which influences the graininess is the degree of development the film receives. Accepting the fact that overdevelopment will also increase the

density of a negative, it is advisable when grain is required to underexpose, otherwise the negative may be unprintable.

The print reproduced here was made from 35mm black and white panchromatic negative material with an ASA rating of 400 to give the desired grain effect. The film was exposed a full three stops under the suggested meter reading and the normal development time of 8min was extended to 16min.

The printed image was selected from only the central portion of the total negative area. This increased the degree of enlargement and, combined with a hard grade of printing paper, further accentuated the overall grainy effect. A condenser type enlarger lens and fine focusing are essential for the critical definition of intentional grain reproduction. (The relationship between three stops underexposure and double normal development time are not standard and will vary with the type of developer used.)

Grain.
A fast film, underexposure, extended developing time and enlargement onto a hard paper increased the graininess of the final image. *Carl Bernard.*

Photo Lettering

The print shown opposite was a proposal for the design of the jacket of this book. The idea was to make up the lettering from enlarged colour transparencies on Cibachrome paper.

A 35mm transparency of red roses was chosen for the words 'PHOTO EFFECTS' and a 35mm transparency of cloudy blue sky for the background and the authors' names.

Three sheets of 10×8in acetate were needed: the first was laid out with the full title in black Letraset; the second with the words 'PHOTO EFFECTS' and the third with only our names were laid out in transparent lettering on a black background.

From this stage onwards a register board was used so that the film layers could be accurately superimposed. Such boards can be bought or constructed at home.

The three pieces of 10×8in acetate and two 10×8in sheets of unexposed lith film (see p. 114) were held together and had holes punched through them with a paper punch. The holes could then be fitted over the pins on the register board. (When handling and developing lith film deep red safelights should be used.)

One of the punched unexposed sheets of lith film and the piece of acetate with 'PHOTO EFFECTS' on it were registered on the board and then contact printed under the enlarger (see p. 92). The exposed sheet of lith film was developed normally. The words 'PHOTO EFFECTS' were clear while the rest of the film was black.

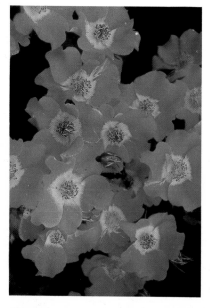 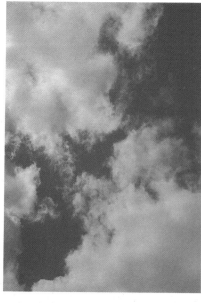

Photo lettering.
The transparencies of roses and sky (*left*) used to make up the lettering 'PHOTOEFFECTS' (*opposite*). *Karen Norquay.*

Similarly the sheet of acetate with our names on it was contact printed in register with the other punched unexposed sheet. When the lith film was developed our names were clear while the rest of the film was black.

The clear sheet of acetate with the full wordage in black was used as a mask when the background blue sky was printed. The sheet of lith film with the words 'PHOTO EFFECTS' on masked all the paper bar the lettering so that the red roses showed through the letter forms while everything else was masked. Similarly, the sheet of lith film with our names transparent was to allow blue sky to show through the otherwise masked out area.

Before the final print could be made, the correct filtration and exposure for each stage had to be calculated. The transparency of the sky was enlarged to the size of the book jacket and a test strip made using the paper manufacturer's filtration and exposure guide. Similarly, test strips were made for the enlargement of the red roses and for the smaller sky area. All three test strips were processed together and the correct filtration and exposure found.

The printing of the final image took a considerable time— three different exposures had to be made on one sheet of Cibachrome paper. The job had to be done in complete darkness as the suggested safelight for Cibachrome paper is safe only for about five minutes (Wratten no. 10 with 15W lamp).

For the final print the transparency of the blue cloudy sky was enlarged and printed onto a sheet of Cibachrome paper in register with the sheet of acetate with the full wordage in black. The paper under the words was thus left unexposed. With the exposed Cibachrome paper safe in a light-tight box, the transparency of the sky, still in the enlarger, was projected smaller to fit the area where our names were to be printed. The partially exposed paper was then placed slightly out of register with the 10×8in sheet of acetate film with our names transparent and exposed to the smaller sky. With the printing paper back in the light-tight box, the roses transparency replaced the sky transparency in the enlarger. Once this was focused on the area where the words 'PHOTO EFFECTS' would be, the enlarger was switched off and the colour paper put in register with the sheet of acetate film with 'PHOTO EFFECTS' transparent on it. The roses were then printed down onto the paper.

The final print was then processed normally. After processing, the areas which had been unaffected by light, due to the positioning of the masks slightly out of register, appeared

Photo lettering. A variety of effects achieved by combinations of lith and Autoscreen films, Sabattier treatment, hammered glass and studio wire. *Carl Bernard*.

Kurt Singer

TALES OF THE UNKNOWN

black and gave a three dimensional effect to the names. This produced the desired effect of the names floating out of the sky.

The photographic production of lettering to create unusual or distorted type characters can be achieved most conveniently at the enlarging stage. There is no limit to creative experiment and there are a number of ways in which one can work. The effects reproduced on p. 71 were achieved by

1. A combination of Sabattier and Autoscreen effects.
2. Printing the negative through textured glass.
3. Printing through a textured screen and convex lens.

A book title, set in dry transfer lettering, was photocopied onto 5×4in lith film and given the Sabattier treatment during processing (see p. 54). The negative was then used to make a 10×8in bromide print which was in turn photocopied onto 5×4in Autoscreen film (see p. 63). This film was also given the Sabattier treatment during processing and it was from this negative that the final print was made.

'Tales of the Unknown' was a title for a book jacket. The words were originally set in Cooper Black from the Letraset range. The overall bold characteristics of this type face made it suitable for this type of distortion work. The title was photocopied onto high contrast lith film and processed in the normal way with lith type developer. Using a 5×4in enlarger, the negative was printed onto a sheet of bromide paper which was under a small sheet of hammered glass. The surface of the printing paper and the glass were in good contact. The resulting image was of a textured and wavy type form. The overall effect of printing through this type of glass can be quite clearly seen in the area below the title.

'Mysterious Worlds' was set in exactly the same way as the previous title and was one of a series done for a book jacket design. Once again lith film was used for the photocopied negative; as an alternative to hammered or textured glass, however, a 'studio wire' was used at the printing stage to create the crystalline appearance within the title words. (Studio wire is a term sometimes used to describe a translucent wire-and-fibreglass filter which acts as a diffuser for studio spotlights.)

The word 'techniques' was set, photocopied and processed in the same way as the previous example. The same 'wire' was used in contact with the printing paper but a convex condenser lens from another enlarger was placed on top of the 'wire' and with the uppermost point of the lens directly central to and above the word 'techniques'.

There are many effects which can be produced by using reeded, hammered or textured glass. Prisms, multiple image lenses and crumpled paper can all be used to create distinctive and unusual type or letter forms. In the choice of distortion technique or process, however, legibility naturally remains the most important criterion.

Abstract Face

While helping a student take close-up facial expression photographs with harsh lighting it occurred to me to take the series of contrasty pictures further until they were almost abstract images.

The barn doors on a spotlight to the side of the model were adjusted to produce a narrow vertical shaft of strong illumination. A fine grain slow film was chosen to heighten the contrast and was developed normally in a fine grain developer. The six facial expression photographs were shot on a $2^1{_4}$in square format camera with two close-up lenses attached. The two strips of three exposures each were contact printed (see p. 92) onto grade 4 printing paper (chosen for increased contrast).

The contact print was rephotographed onto a sheet of 5×4in lith film which was then developed in a corresponding lith type developer. (When developing lith film only deep red safelights should be used.) The lith film eliminated all the mid tones left in the contact print, leaving only black and white. A positive lith transparency was made by contact printing the lith negative onto another sheet of 5×4in lith film.

Part 1 of the image is the lith negative enlarged and printed onto a 10×6in sheet of printing paper.

Part 2 is the lith positive transparency enlarged and printed onto a 10×6in sheet of printing paper.

Part 3 is the lith negative and positive transparency of parts 1 and 2 sandwiched together slightly out of register and contact printed onto 5×4in lith film to give a fine line negative. This negative was then printed on a 10×6in sheet of printing paper to give a fine black contour on white.

Part 4 is the final negative in part 3 contact printed onto a sheet of 5×4in lith film and developed. This lith positive transparency was in turn printed on a 10×6in sheet of printing paper to give a fine white contour on black.

All four prints were then mounted together.

Abstract face.
Overleaf: a series of portraits manipulated to produce an almost abstract combination by using lith film and printing out of register. *Karen Norquay*.

Transparency processed as negative

Unlike colour negative film, colour transparency film has no overall orange mask to control contrast. By processing colour transparency film as if it were colour negative, high contrast prints can be produced. The subject appears in complementary colours and exploitation of this fact can result in extraordinary colour effects.

Skin tones and sky print as yellow, clouds print as black and vegetation prints as magenta. If high contrast is the only objective, the filtration can be manipulated at the colour printing stage to produce an almost normal colour print, albeit contrasty. The film should be underexposed by one *f* stop when less contrast is wanted.

Infra-red transparency film can be processed in the same way. Living vegetation which would, as a rule, appear magenta on this film reproduces as green but the other colours in the subject will reproduce as their complementaries. Infra-red film is quite contrasty and the contrast is exaggerated by processing the film as a negative. Underexposing the film by one and a half *f* stops will counteract this.

Commercial colour printers will process and print Ektachrome as colour negative but, as only a few colour laboratories will process infra-red colour transparency film conventionally, it is even more difficult to find someone who will process it as colour negative. Infra-red film must be processed at temperatures lower than that of present day colour negative film.

The only way to get round this problem is to process infra-red film on its own at home using either bought chemicals or those that would otherwise be discarded by a colour printer when replenishing.

Transparency processed as negative. The high-contrast effect achieved by processing 400ASA Ektachrome as colour negative film and printing directly onto Cibachrome. A print from the same negative printed as if it were a normally processed negative is shown in the lower picture. *Karen Norquay.*

Paper Negative

A paper negative is one which has been made with light sensitive printing paper as opposed to film. A latent image on paper can be achieved in exactly the same way as an image on film, ie via a lens within a camera, from existing film material and printed from an enlarger, or by contact printing from a film or a paper print. If the paper is to be used within a camera, it is worth remembering that, with the exception of one or two designed for making black and white prints directly from colour

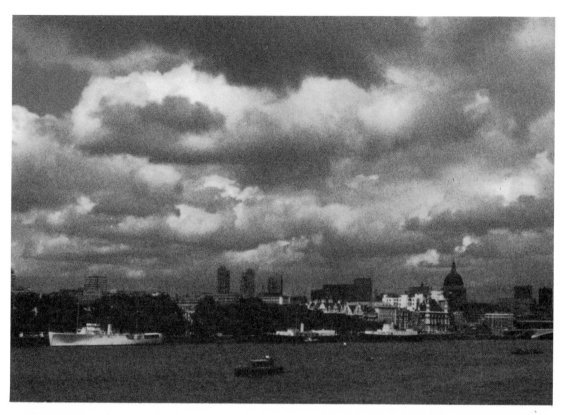

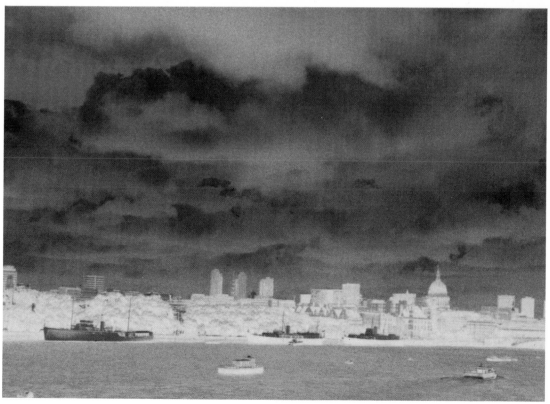

negatives, most printing paper is not sensitive to light in the same way as film is; the approximate ASA speed is extremely slow, somewhere in the region of between 3 and 10ASA. This means that long exposures are necessary and this obviously influences the choice of subject matter.

A convenient method of producing a paper negative is to photograph an original print, using paper instead of film stock.

The print of a girl's face reproduced here was originally a 10×8in black and white bromide print, made in the normal way from a 35mm negative. The print was photocopied using light-weight document type printing paper that had been cut down to the exact size of 5×4in film and used in a double-dark slide as the alternative to cut film. Two copy exposures were made, one from an estimated exposure based on a film speed of 3ASA and one based on 10ASA. With the illumination used at the time, the two exposures given were in fact 4sec at *f*16 and 12sec at *f*16.

The two paper negatives were then developed in a universal type paper developer for approximately 2min. After fixing, washing and drying it was decided that the denser of the two negative prints was more suitable for use. The next process was to make the paper negative more translucent by soaking it in paraffin and drying out before printing.

A condenser type enlarger was used to make the enlarged print in order to provide a more concentrated light source. The print was made in the same way as a normal 5×4in film negative would be printed. A small area of the paper negative was enlarged and a high contrast paper was used to try and emphasise the actual paper structure within the negative. A low or medium grade of paper would probably have been suitable for greater detail within the paper but the overall image would then have lost a great deal of impact.

Contact printing from existing paper prints, which reverses the tones, to make negative prints can sometimes produce interesting qualities. Marks that are immediately obvious because of their positive factor become less so when reversed.

Paper negative.
Printing paper can be used in the camera instead of film but the exposure must be much longer. *Carl Bernard.*

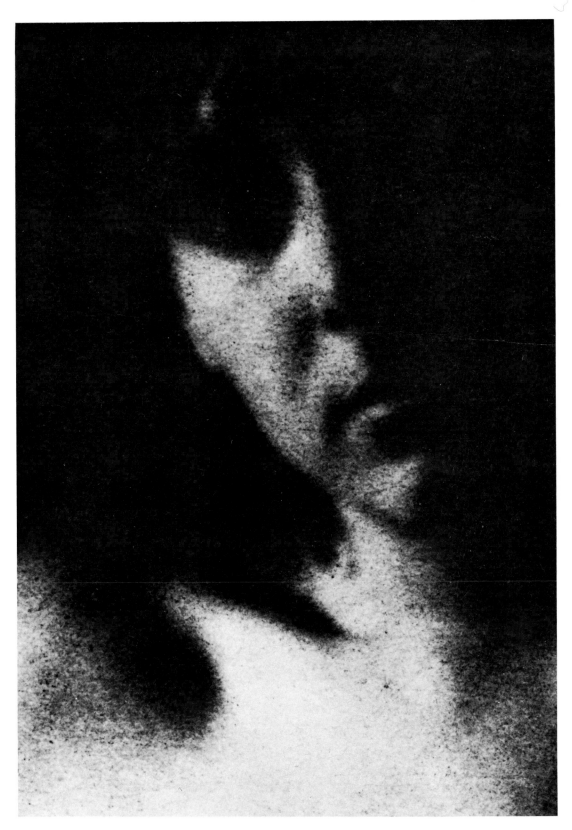

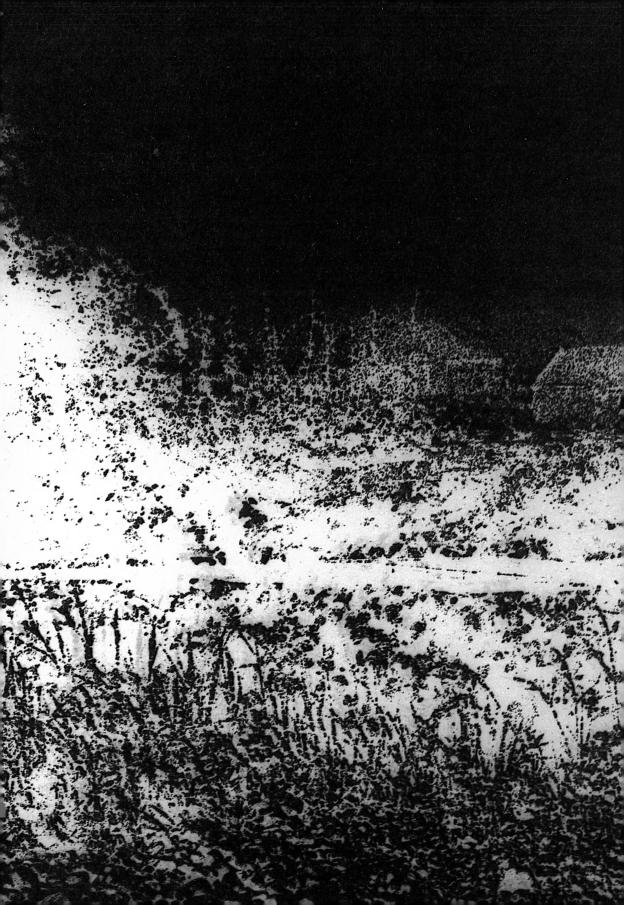

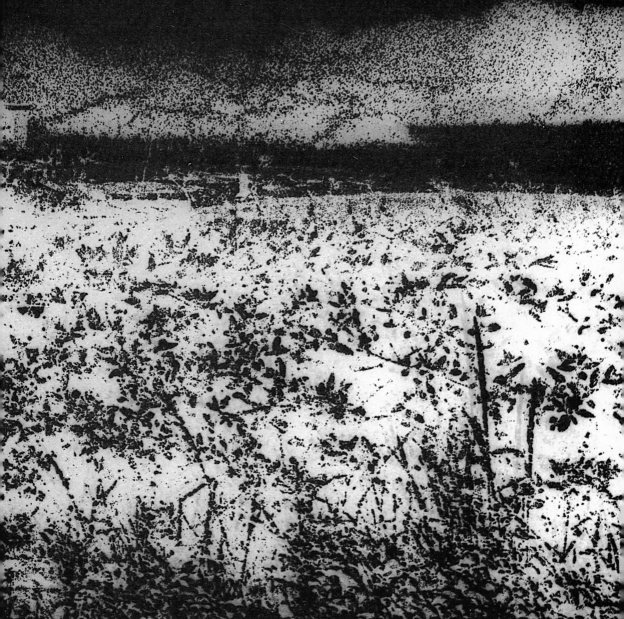

3
The Darkroom

Introduction

Many weird and wonderful effects can be managed in the darkroom. Once the basics are known, there is no end to the variations possible.

The darkroom does not need to be painted black but it must be light-tight and well ventilated. There should be two separate areas: a wet area for three processing dishes, and a dry area for an enlarger and for handling negatives and paper. Running water for washing, a thermometer, a timer, a masking frame to hold the printing paper flat, and a brush and an anti-static cloth to clean negatives are all necessary.

An ordinary white light source is sufficient for contact prints or photograms, but larger prints can only be produced with an enlarger. Light from the enlarger bulb is directed through the negative and focused on the baseboard by a lens. In some enlargers the source light is diffused by a sheet of cloudy glass set above the negative; others have condenser lenses that centralise the light on the negative. The diffusion types tend to soften detail; the condenser types give good detail and contrast and a very sharp image.

For each print a test strip should be made. The negative is placed in the enlarger and focused on the baseboard. With a yellow filter over the lens, a strip of printing paper is placed across a representative part of the image and, with the filter removed, a range of exposures is made.

When the strip has been developed, stopped and fixed, it can be assessed. It is at this stage that skill and judgement are needed. Tones can be exaggerated or diminished by careful choice of the grade of printing paper used for the final print: Grade 2 will produce soft grey tones; Grade 5 will produce a very hard, contrasty effect. The details of the print or aspects of the subject matter can also be manipulated at the printing stage by dodging. For extra detail in the sky one's hand may be sufficient for this but a more exact method is to use a card mask cut to the shape of the area that needs less light.

Resin-coated papers require relatively short processing times and do not need a dryer. However, many special effects are difficult with this paper: toners do not soak in readily and retouching is awkward.

If a dryer is not available for bromide prints they can be stretched to dry by taping them down flat on boards, but a small area of the print will be lost on removal.

K. N.

Lith negative.
Previous spread: print from a lith positive transparency made from 35mm negative (see p. 114). *Carl Bernard.*

Sabattier print.
Right: the Sabattier effect is produced by exposing a print to light during development. *Carl Bernard.*

Sabattier Print

A Sabattier (pseudosolarised) print is one which has undergone a similar treatment to the Sabattier negative described on p. 54. The visible difference is that there will be no white areas within the print as the intermediate fogging takes place during the production of the 'positive' print (fogged or dark areas within a 'negative' will be reversed when a print is made).

The print reproduced here was exposed to a white light from an overhead light source when normal development was complete. (At this stage, any other light-sensitive material in the darkroom must be covered.) The fogging exposure lasted approximately 1sec. The final effect within the print was achieved with a further 1min development. The print was then transferred to stop bath and fix.

This type of image treatment is more suitable for subjects of high contrast and where there is not a great deal of fine detail. The abstract and close-toned quality of the Sabattier print is for visual effect rather than a realistic or informative image.

Sabattier Cibachrome

The cabaret singers were very flamboyant and the small room in which they worked was full of mirrors and gold filigree. It seemed that the Sabattier effect would accentuate the bizarreness of the pictures.

 A direct flash with a wide angle attachment was used to

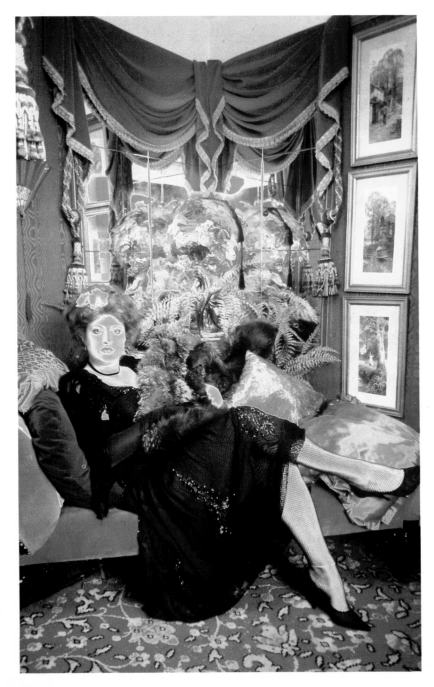

Sabattier Cibachrome
Left and opposite: Cibachrome prints from a 200ASA daylight transparency film given a Sabattier treatment during development. *Karen Norquay.*

light the subject and the transparencies were processed
normally. It is safer to have the original transparency intact and
to experiment with Cibachrome printing as below or with inter-
negatives made from the transparency.

 Both images were given the same treatment. The
transparency of the girl was enlarged and a test strip made on
Cibachrome paper using the recommended filtration and

exposure guide on the pack. It was developed, bleached, fixed, washed and dried.

Dishes were chosen for processing in preference to the normal drum method as this made the later fogging of the print during development easier. Rubber gloves should be worn.

Another test strip was exposed. The transparency was taken out of the enlarger and the empty carrier replaced. After half a minute development, the test strip (still in the developing dish) was placed under the enlarger. Half of the strip was exposed to light for 1sec and the other half for 2sec.

The strip was developed for a further one and a half minutes, bleached, fixed, washed and dried. The part of the test strip that had been fogged for 2sec seemed to have the best mixture of both positive and negative images.

The final print was made by exposing it to the enlarger light for 2sec after half a minute development, developing for a further one and a half minutes and then processing normally.

Lith Print

The photograph was taken in the tropics just before torrential rain; it was made more dramatic by darkening the blue sky with a red filter.

Blue sky appears too light on monochrome films because the emulsion is more sensitive to blue than to yellow. By using a yellow filter to absorb some of the blue light, white clouds will stand out from the darkened sky. The darker the filter, the greater will be the contrast between sky, clouds and landscape. A red filter will absorb so much blue that the sky will appear almost totally black. A pale yellow filter will reduce the haze caused by an excess of blue in a distant landscape.

The picture was shot on a medium speed film which was processed normally in a universal type developer and printed onto lith paper. (A deep red safelight should be used when handling lith material.)

When printed from a normal monochrome negative and processed normally, lith paper produces a high contrast print with strong blacks and very little tones. If the exposure is more than usual and the development less, however, then the result is reduced contrast and brown tones. Accurate test strips should be made as colour assessment is difficult under deep red safelight.

The print illustrated was given twice the normal exposure and underdeveloped.

Unfortunately the manufacture of lith paper has been discontinued and it is becoming hard to find. Although more time-consuming, another process gives similar results.

A normal print should be made on a soft grade of bromide paper so as to bring up all the tones and then re-photographed on 5×4in line film (lith film is too contrasty). The size the image should be on the 5×4in line film depends on how grainy a picture is wanted. An image in the middle of, rather than filling, the line film negative will give the appropriately grainy effect when enlarged.

This negative should be overexposed in the camera and underdeveloped in a universal type developer.

Test negatives must be made so that the exposure and development times can be determined exactly.

The final print can be made on a chlorobromide paper which gives warm, almost brown, tones, or it can be printed on hard bromide paper and sepia toned.

Lith print.
A black and white negative printed on lith paper with twice the normal exposure and underdevelopment to produce brown tones.
Karen Norquay.

Fogged Colour Print

Fogged colour print. Exposure to a yellow safelight before development enhanced the violet hue given by the cyan and magenta filtration. *Karen Norquay.*

The girl in the photograph was a fashion designer. The living room and her dress were full of bright colours. In order to convey this effect, harsh lighting was used and the print was given a colour cast of violet—her favourite and the most predominant colour in the room.

The subject was lit by direct flash with a wide-angle attachment to combat fall-off.

Initially the idea was to print the processed transparency onto Cibachrome paper with a magenta and cyan filtration colour bias but, after numerous test strips, the desired violet could not be obtained.

Whilst making one of the test strips, the paper was accidentally and briefly affected by the dim white darkroom light; after processing, the desired violet effect emerged on this sheet. The first yellow dye layer of the Cibachrome paper had been completely fogged, leaving some magenta dye on the layer below and a considerable amount of cyan beneath that, rendering the test strip a bright violet colour. This process was repeated with the final print.

It is advisable, however, to persevere with altering the filtration when a particular colour bias is required; the fogging process used above is hard to control.

Diffuse Print

A diffuse negative or print can be achieved in many different ways. The general effect is a softening of an otherwise sharply defined image. The diffusing process can be introduced either at the picture taking stage or when the print is being made.

Diffusion is a process which is not always applicable to all subjects and is most commonly used in portraiture. Here, however, the technique seemed to be an appropriate and effective way of reproducing the vase of flowers.

The diffused print shown on p. 90 with the undiffused original inset, was printed through a diffusing screen. A piece of nylon stocking 4in square was stretched and taped over a hole 4in square cut from a piece of black card.

This screen was placed between the enlarger lens and the print easel during the exposure. The original exposure time of 10sec (for the normal print) was increased by 50% and the diffusing screen introduced after the first 5sec. The subsequent stages of print finishing were carried out as normal.

The amount of diffusion can be controlled by varying the time elapsing before the screen is introduced and varying the density of the mesh in the stretched nylon stocking.

All methods of diffusing give slightly varying qualities and it is usually a matter of personal choice or suitability as to which one to use. Petroleum jelly smeared across a piece of glass and held in front of the lens at the picture taking stage is another fairly common way of diffusing an image; it is a particularly effective way to diffuse the edges of a picture while the central portion remains sharp.

Diffusing at the printing stage has the advantage that the negatives can also be used for making normal prints.

The diffusion effect can then be combined with others such as high key or vignetting.

Diffuse print.
Printing through a diffusing screen softens the final image. The inset shows the undiffused print. *Carl Bernard.*

Distortion Print

A distortion print is one that is made with the negative or printing paper held in a warped or distorted position, ie not in the conventional flat plane. The most convenient method is to hold the printing paper in a curved plane during exposure, which was the technique used to make the print shown here.

The printing paper was positioned under the enlarger and held in place by one small lead weight at each corner. With the enlarger safelight filter across the lens, the negative was focused on the uppermost point of the printing paper.

The required exposure time was relatively long as a very small aperture had been selected on the enlarger lens. The small aperture was necessary to increase the depth of the image

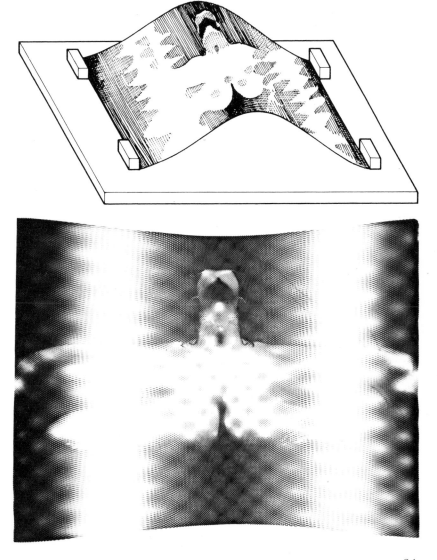

Distortion print.
Lead weights were used to hold the printing paper in a curved plane during exposure. *Carl Bernard.*

sharpness across the printing paper surface. Since the edges of the curved paper are further from the light source than the centre some shading may be necessary to maintain an equal exposure across the print although this does depend on the effect required.

If a straight enlargement had been made the image size on the baseboard would have been approximately 15×12in. When focusing on the top surface of the printing paper, however, the overall image size was reduced to approximately 10×8in. The negative used for this print was on 5×4in Autoscreen film and this caused the closely packed elliptical dot formations and moiré effects.

The original print from which the Autoscreen negative was made was printed from a 35mm negative that had been shot from a camera with a wide angle lens. This was a premeditated process intended to exaggerate the image distortion from the outset. The female nude figure although transformed to an essentially abstract form is still discernable.

The most suitable subject for this type of effect need not always be a nude female figure. Almost any subject matter will provide satisfactory results although portraits tend to be transformed into ugly shapes and very unflattering likenesses.

Negative material can also be distorted, although in a more limited way than prints because a fairly flat plane must be retained within the enlarger negative carrier. Negatives can be 'stretched' by various forms of heat treatment which soften the emulsion.

Contact Print

Straightforward contact printing is the rule after a film has been processed.

The best way to contact print the negatives is to cut them into strips and lay them onto a 10×8in sheet of photographic printing paper in the darkroom. (This should be done under yellow safelights.) By arranging the strips carefully a whole 35mm or 120mm film should fit onto this size of paper. Place a piece of glass larger than 10×8in on top of the negatives to hold them in contact with the paper. Expose the paper to white light either from the enlarger or by switching on the room light. A test strip should be made to determine the correct length of exposure. When developed, fixed and washed, each frame of the finished print can be examined; those worth enlarging can be chosen and their framing decided. The sheet should be kept with the negatives as reference.

Contact print.
Cut strips of negatives were carefully positioned on printing paper and held in place by a piece of glass during exposure.
Karen Norquay.

In order to portray the range of movement of the conductor a series of photographs of him were shot at about 30sec intervals without changing the position of the camera and on a slow shutter speed. A tripod was used to combat camera shake.

Because some images are more compelling in sequence, it was decided to print a number of the shots together. Instead of contact printing the negatives, the strips were laid out and sandwiched between a 10×8in glass negative carrier and

enlarged onto one sheet of normal contrast printing paper. This effect can only be achieved if all the negatives are of about equal density and little dodging (see p. 110) is needed. Very large contacts can be made in this way for critical inspection of small details in each frame or if only small rough prints of each negative are wanted. If an enlarger which takes 10×8in negatives is not available then a similar contact can be obtained when a normal contact is made and re-photographed onto a 5×4in, 2¼in square or 35mm negative which, in turn, can be blown up to the size required.

Combination Print

A combination print is usually a single print made from more than one negative of separate subjects. It is one method of producing an image of contrasting or ambiguous forms or, by skilful technique, of harmonising two or more compatible images.

The print reproduced here was made from two separate negatives of views taken in the town of Bath. The negative of the background shot was enlarged to approximately 15×12in landscape format. A test strip was then printed and developed to assess the proper exposure. The next step was to insert a sheet of 15×12in printing paper in the print easel and to position (under the enlarger safelight filter) a piece of black card (cut to approximately 4×8in) over the area where the second image was to appear. This card was held in position by four small lead weights while the print exposure was made. After exposure the negative was removed from the enlarger and replaced by the second negative without touching or moving either the printing paper in the easel or the card mask. The exposed print surface was then completely masked by carefully butting up sheets of thin black card to the 4×8in mask and stabilising them by using more small lead weights. The central mask was then removed from the print surface, leaving all but the area for the second negative printing completely masked out. Using the safelight filter once again, the image of the second negative was focused on the unmasked area. After selecting a suitable size and composition for the second printing, the central mask was carefully replaced and another test strip made to assess the exposure for the second printing. The central mask was again removed and the exposure made for the final print. Finally, all the masking cards were removed and the print

Combination print. Careful masking of the printing paper for each exposure allows two images to be combined (see diagram opposite). *Carl Bernard.*

94

First printing: central
mask in position.

Second printing: surround
masks in position.

was developed and fixed normally.

This method of combination printing requires very careful attention to the masking process. Any imprecise alignment of masking cards will be evident in the final print, as will any imbalance in exposure between the two print images.

Image Mask

Image masking is a more graphic and sharper alternative to vignetting. The process of cutting shapes from black card is the same, although greater care has to be taken when cutting out to ensure that all edges are clean and sharp. During printing the mask is in direct contact with the surface of the printing paper and any flaws will be clearly defined and visually detracting.

The two examples shown were produced by using two acetate masks that were available a few years ago for use in conjunction with a single negative contact printing light-box.

The contact printing paper (with matt finish) was positioned on the enlarger baseboard beneath the lens and light source. The single cut negative was then laid on top of the paper, emulsion to emulsion. The mask was then laid on the negative and a sheet of glass laid on top to ensure contact between mask, negative, printing paper and baseboard.

When using glass for contact printing without any form of clamping or vacuum suction, it is advisable to use 36oz plate glass otherwise there will be imperfect contact between the negative material and printing paper.

The exposure was made as for normal contact prints. After being washed, dried and mounted on card, both prints were coloured with soft crayon, which takes well to a matt finished surface.

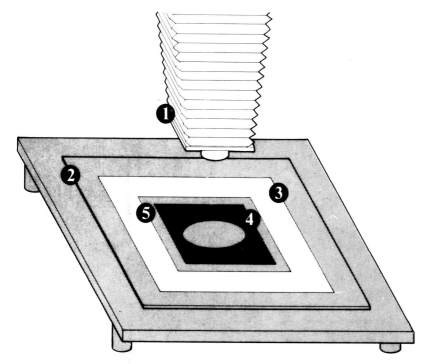

Image mask.
Left: arrangement of masks. 1, enlarger; 2, 36oz glass; 3, printing paper; 4, mask; 5, negative.
Right: two masked prints mounted together and coloured with soft crayon. *Carl Bernard.*

Multiple Image

The print reproduced here was made from one negative but the procedure was the same as that for the combination print on p. 94.

Multiple image.
A combination print (see p. 94) cut into three and the parts repositioned and mounted. *Carl Bernard.*

The smaller central image of the child was printed through an overall surround mask and the larger image was an enlargement taken straight from the same negative. This overall larger image was then printed with the central mask repositioned (as in the combination print). Tests, prints and processing were also carried out in the same way as for the combination print. The final stage was to cut the print with two vertically angled lines either side of the smaller central image. The left-hand and right-hand image strips were then transposed, ie left to right and right to left. Before being mounted, the three elements were moved along their butted-up lines to re-align the background structure so that there was a more continuous line throughout the overall picture.

The cutting and re-positioning of prints is an alternative to the conventional and formal way of print presentation and is one way of using one or more photographic images in a single picture. For example, a series of exposures taken of a landscape by 'panning' the camera around in a lateral line can produce a panoramic type image. The prints, whether in contact form or enlarged, are mounted side by side and eventually become one continuous and related image. A tripod is essential for this effect in order to retain the fixed viewpoint.

When cutting or trimming prints for whatever purpose, it is always very important to ensure clean sharp edges. A good cutting blade and steel straight edge are preferable to guillotines because of the degree of control that can be retained.

First exposure: surround mask in position. Negative printed through central aperture.

Second exposure: negative enlarged. Central mask in position. Surrounding areas exposed.

Combination print cut into three, and the left and right parts transposed.

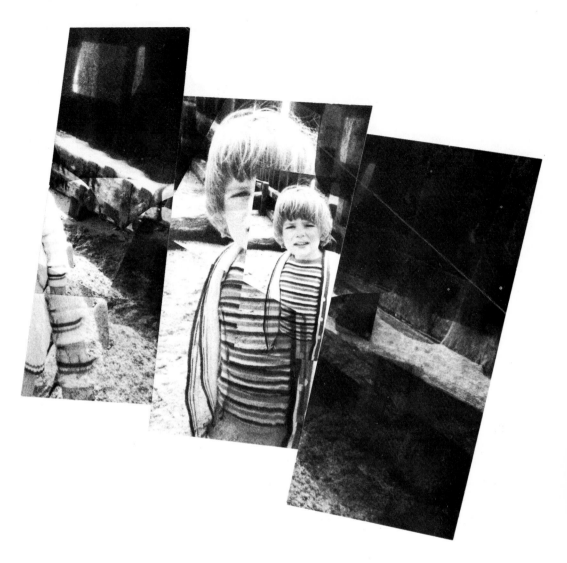

Multiple Colour Print

A multiple print was chosen to give an impression of the dancers' rapid and complex movement. The photographs were taken while the dancers were being filmed for television. The lighting used by the TV company had the colour temperature of daylight and was therefore suitable for the daylight/flash transparency film being used.

The film was deliberately overexposed by one *f* stop and processed normally. The processed transparencies were laid on a light-box and, by experimenting with laying one transparency over another, an assessment of the likely results of multiple printing on Cibachrome paper was made. The two suitable transparencies were sandwiched together in a glass negative

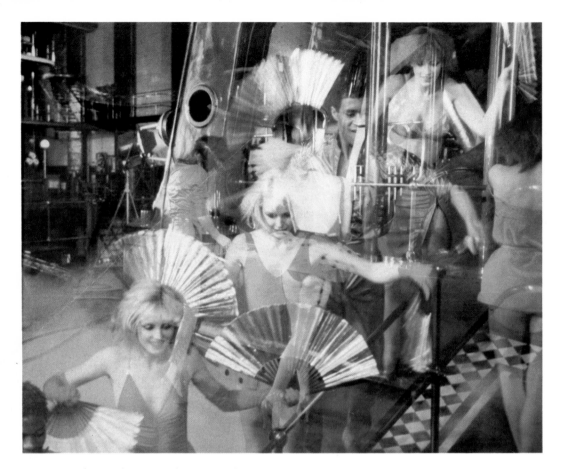

carrier to keep them as close together as possible.

The combined image was enlarged and a test strip made on Cibachrome paper using the manufacturer's recommended filtration and exposure. As two overexposed transparencies are almost equivalent to one correctly exposed one, no great adjustment to the manufacturer's exposure was necessary. The final print was then made using the correct filtration.

Colour temperature is a scale that describes the colour composition of a light source. For the above picture, the actual temperature of the lighting was found out from one of the TV lighting technicians but there are colour temperature meters available that will show whether a colour correcting filter needs to be used to match the light source to the film being used.

Colour correcting filters work by absorbing light of a particular colour that is too predominant in a light source. There is a blue series and a red series of such filters: the blue ones increase the colour temperature and the red ones lower it. An orange (type B) filter will make film designed for use in a tungsten light source suitable for use in daylight. Similarly, a blue filter will enable daylight film to be used in tungsten light.

Multiple colour print.
Above: two overexposed transparencies mounted and printed together. *Karen Norquay.*

Semi bas-relief in colour.
Opposite: a colour negative and a black and white lith film positive made from it, sandwiched together slightly out of register and printed onto colour paper. *Karen Norquay.*

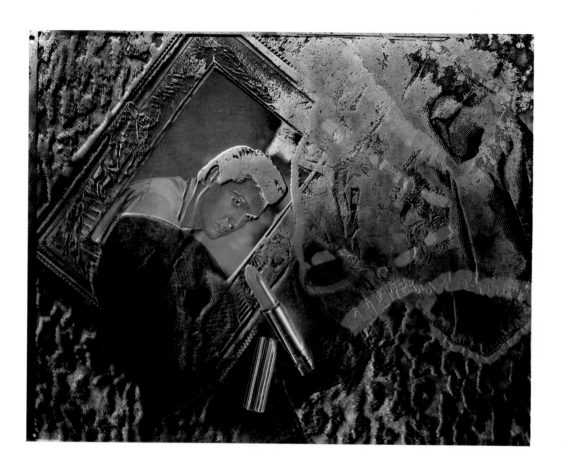

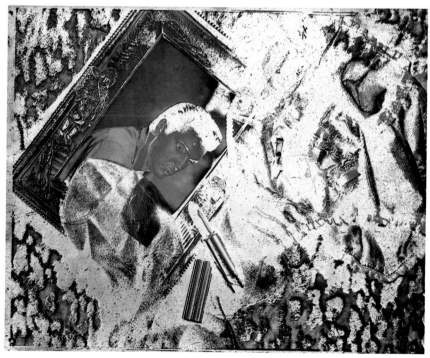

Semi Bas-relief in Colour

Semi bas-relief is a darkroom technique that changes a straightforward colour image into what looks like an almost three-dimensional image. As with black and white bas-relief, the original negative and a film positive of the same size made from the original negative are sandwiched together slightly out of register.

To produce the picture shown on p. 101, the film positive was made with black and white lith film instead of a similar type of colour film to the original. This method makes bas-relief in colour printing relatively easy since lith materials can be handled in deep red safelights. A 5×4in colour negative was used in this instance because large sized film is easier to handle, but similar effects can be attempted with smaller format negatives, eg 2¼in square and 35mm.

To make the positive the colour negative was contact printed (see p. 92) onto a sheet of 5×4in lith film. A suitable positive was made by experimentation. One both overexposed and underdeveloped (in lith developer) offered the most interesting effect when sandwiched together with the original negative. This positive had many more tones in it than a normally exposed and developed sheet of lith film and was lower in overall density than the original negative.

The same size negative and positive were registered, emulsion, to emulsion, and then slightly offset.

It is advisable to use a glass carrier to hold the two sheets of film in close contact if enlargements are required. To make the picture illustrated, the sandwiched negative and positive were contact printed onto colour paper.

Chemical Imagery

Chemical imagery is a way of obtaining abstract tonal images on light sensitive paper without the use of any lens to form an image but by the use of chemicals alone.

A sheet of printing paper is exposed to an unsafe light source in the darkroom or for a few seconds in daylight. The sheet is then screwed into a ball which will be about the size of a golf ball if 10×8in paper is used. It is then immersed in a tray of fix solution and rolled around for a few seconds until the solution has penetrated into the ball of paper. The paper is then withdrawn and squeezed tightly to 'wring out' the excess fix. The print is then developed in a tray of developer until an

Chemical imagery. An exposed piece of printing paper screwed up, rolled in fix solution and then developed normally. *Carl Bernard.*

abstract tonal pattern emerges. (The contaminated developer should be disposed of immediately after use.) The print is then fixed, washed and dried in the normal way. The print will contain totally abstract patterns ranging from white to black and with many subtle intermediate shades of grey; close inspection will reveal many random mirror images which are due to the offsetting of chemicals when the paper was squeezed.

The technique in itself could be interpreted as rather inconsequential and lacking in controlled image processing. The results, however, have a certain value, if only for an understanding of the effect of chemicals upon light sensitive materials.

Contrast in Colour Prints

Unlike the wide range of papers available for printing black and white photographs, paper for colour prints from colour negatives only comes in one grade of contrast and in one base colour—white.

The paper is sensitive to the primary photographic colours, blue, green and red. Any adjustment to colour, when printing, can be controlled by yellow, magenta and cyan filters in the colour enlarger.

The structure of colour paper is similar to that of colour negative film but colour paper lacks the orange mask which controls contrast and colour reproduction.

Colour paper should be handled in complete darkness or under a deep amber safelight. Processing of colour paper can be tackled in daylight after the exposed paper has been loaded in a light-tight drum in the darkroom.

One way of boosting the contrast in a colour print is to sandwich it with a same size lith negative made from a colour negative. To arrive at a same size negative an intermediate lith positive is necessary. A lith positive is produced by contact printing the colour negative onto a sheet of lith film.

Once exposed and processed, the lith positive can be contact printed onto another sheet of lith film to make a same size lith negative. At this stage, however, the lith negative must be slightly underexposed: a normal density lith negative would completely overpower a coloured negative.

The low density lith negative and colour negative sandwiched tightly together and either contact printed or enlarged onto colour paper will produce a contrasty colour print. The less dense the lith negative is, the less contrasty the colour print will be.

Contrast in colour prints. Printing a colour negative sandwiched with a same-size lith negative of the image increases the contrast. The lower picture is a straight print from the colour negative. *Karen Norquay.*

High Contrast Printing

Photographic printing paper is coated with a light sensitive emulsion similar to that used for negative materials. However, paper emulsion is generally much slower and less grainy than film emulsion. Whereas black and white negative materials are sensitive to the full range of colour in the picture, printing papers need not be. They are generally sensitive only to the blue end of the spectrum and therefore can be handled and processed under orange or greenish yellow light.

Bromide papers, which have silver bromide suspended in the emulsion, are the fastest and most popular type of printing paper.

Chlorobromide papers have both silver bromide and silver chloride in them, though the proportion of each may vary from paper to paper. These papers tend to give a warmer tone to a print but the contrast may be lower than with bromide papers.

These light sensitive emulsions are coated onto many types of paper with differing surface finishes and colours. The emulsion itself can be coated onto plastic, linen, wood etc. Choice of paper depends on personal preference. Matt, semi-matt, silk, stipple and glossy are just some of the finishes available.

Surface texture affects the character of the print. A smooth finish offers maximum detail while rough surfaced prints will conceal graininess and fuzziness. Glazed glossy prints offer a more intense black than other finishes. Papers also come in different weights, the most common ones being single weight and double weight. It is not advisable to make very large prints on single weight paper as it is likely to crease.

In order to print from negatives of differing degrees of contrast, printing paper is produced in various grades. The choice of grade is determined by the type of negative or the effect desired or both. The widest range offered by any manufacturer is as follows:

Grade 0 Very soft
Grade 1 Soft
Grade 2 Normal
Grade 3 Hard
Grade 4 Extra hard
Grade 5 Very hard

High contrast printing. Harsh lighting, medium speed film, fine grain developer and hard printing paper were combined to give these high contrast images. *Karen Norquay.*

The characteristics of these grades vary from manufacturer to manufacturer and all the grades may not be available at any

one time. Grades 2, 3 and 4 are the most popular. Experience of one manufacturer's paper and a knowledge of which grade of paper suits a particular negative density is something to work on.

The photographs illustrated are part of a series on chairs. The fact that the subject matter linked the pictures was not enough. To emphasise the point, they were all given the same print quality.

High contrast was the objective. The chairs were photographed in as harsh light as possible (usually direct sunlight) on a medium speed film which was processed in a fine grain developer. The fairly contrasty negatives were all printed on either hard or extra hard paper. These grades of paper offer few grey tones but intense blacks and whites.

The high glazed finish of the resin coated paper further exaggerated the contrast. This plastic coated paper is waterproof so that the time of development, fixing and washing can be much less than with normal bromide paper. One that dries with a high glossy finish was used here but other surface finishes are also available. To ensure good blacks the prints were given slightly longer than the normal development time.

Low Contrast Printing

Sometimes it is difficult to retain the atmosphere of a scene when the time comes to print. The photograph opposite was taken on an overcast rainy day in the Scottish highlands. In order to capture the full range of tones, care was taken to calculate exactly the right exposure for the medium speed film being used. If the negatives had been overexposed or overdeveloped, no amount of printing in on soft paper (Grade 1 or 2) would have produced the full tonal range of perfectly exposed and processed negatives. If at all in doubt, bracket by one stop over and one stop under the aperture indicated by a light meter reading.

The medium speed film was processed in a universal type developer. Chlorobromide printing paper was chosen to print on as it has good tone separation and is slightly brownish/black in colour—ideal for landscapes. When working with chlorobromide paper, the colour and contrast of the print can be controlled by the amount of development given. It develops at a faster rate than normal bromide paper, making underdevelopment possible. The shorter the development, the warmer the tones become. When processed for a sufficient time,

the action of the silver bromide increases causing true blacks to appear on the print.

Unfortunately, when shooting the scene here, a UV filter was used to protect the lens from the rain and wind. This meant that most of the atmospheric haze was lost. The fast shutter speed eliminated the rain as well. It was important to put the haze and rain back into the final print somehow.

A cold cathode enlarger with its soft, even light was preferred to the harsher and more contrasty condenser type enlarger. The final print was overexposed in the enlarger and whisked in and out of some exhausted developer (saved from previous black and white printing) in 10sec. Developer becomes exhausted when all the developing agents have been used up and this brownish solution can stain sensitised materials. The brownish liquid flowing over the print left some faint staining and gave the landscape its distinctive appearance.

Low contrast printing.
A cold cathode enlarger and short development in exhausted developer recreated the atmospheric haze of the original landscape. *Karen Norquay.*

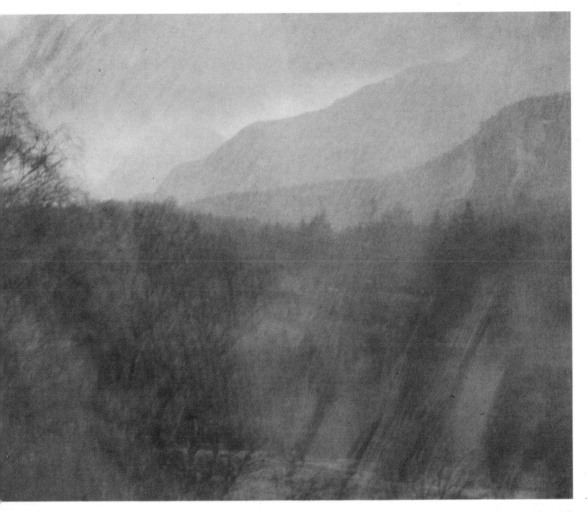

Printing-in

'Printing-in' is a term used for controlling print exposure when it is desirable to give more than the overall general exposure in order to improve the graphic or 'straight' quality of a photographic print. The effect provides perhaps the most obvious impression when used for images that contain very intense highlights such as bright lights or the sun. There are two alternatives for 'printing-in' highlights such as these. The first is to 'hold back' the area outside that of the highlight point and restrict the extended exposure to the bright spot. The second is to increase the exposure overall which has the effect of making all areas other than the highlight go dark. The amount of overall exposure can be carried to the extreme of almost total image extinction if the subject matter will stand up to it in visual terms.

The photograph reproduced here is an example of increasing the dramatic effect of an otherwise conventional landscape photographed under a setting sun. The printing exposure for a 'straight' print was increased four times and had the effect of more clearly portraying the sun and its radiant effect. The image is consequently very subtle and it is the subtlety alone which gives it its particular quality.

Printing-in.
Increased exposure at the printing stage enhanced the dramatic effect of this image. *Carl Bernard.*

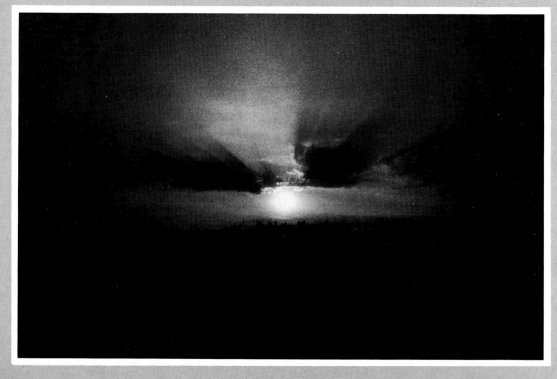

Multiple Mask

Multiple mask is a hand cut masking method for repeated image production from one negative onto one sheet of printing paper. By altering angles or selecting more or less of an overall image it is possible to convey a totally different view of an otherwise conventional and straightforward picture.

The photograph of a horse's head illustrated here was selected as a possible image for repeating in a short sequence to suggest movement.

A series of rectangular apertures were cut from a sheet of black card measuring 10×8in. The apertures were spaced within the overall format in the positions that the images were to be printed. The cut mask was placed on top of a sheet of 10×8in printing paper and put under the enlarger with the safelight filter in position. The negative of the horse's head was then projected and focused within the left-hand aperture. The horse's head virtually filled the 35mm negative format and consequently there was no unwanted image or light falling upon the other apertures. After removing the safelight filter and making the first printing exposure, the filter was replaced and the combined mask and printing paper moved to the second aperture. The horse's head was composed for the second exposure. This

Multiple mask.
Single exposures made through each of four apertures cut in a sheet of black card. *Carl Bernard.*

process was continued until all four images had been individually composed and printed.

By varying the angle and placing of the horse's head within the series of mask apertures there appeared a subtle impression of movement and of more than one negative having been used. If a detail within a larger overall negative had been required it would probably have been necessary to mask out the other apertures during the printing of any single one.

When the printing was complete, the cut mask was removed and the print developed, fixed, washed and dried.

Vignette

To vignette a print is to 'fade out' the picture edge, allowing the image to merge gradually into the background with an irregular and soft edge between the two. A variety of shapes are possible but the two most commonly used are circular or oval. Owing to the rather romantic effect of the print image, vignetting is a technique often chosen for portraiture of one sort or another.

The vignette print shown here was produced by interposing, between the enlarger lens and print easel, a sheet of black card

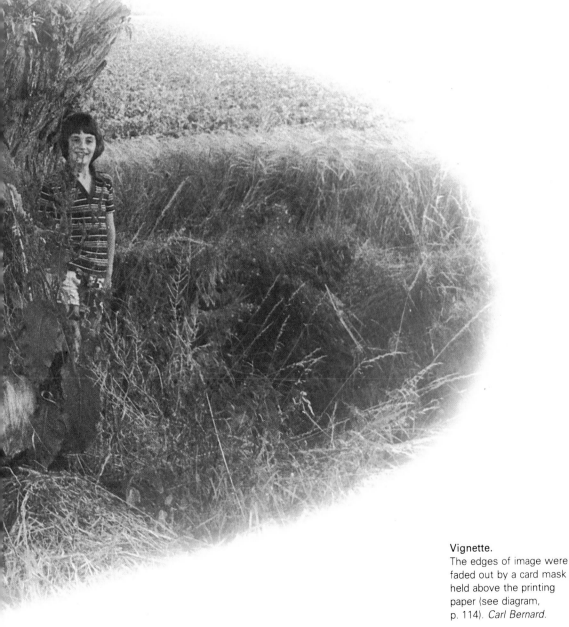

Vignette.
The edges of image were faded out by a card mask held above the printing paper (see diagram, p. 114). *Carl Bernard.*

Arrangement for vignetting: the vignette card with central cutout is held about 4in above the printing paper. The card is rotated slightly backwards and forwards to soften the edges of the image.

from which had been cut a pre-selected shape. The size of the whole was slightly smaller than the finished image size was required to be. During the printing exposure the vignetting card was held approximately 4in from the easel and rotated very slightly to produce the soft edge. The print was eventually sepia toned (see p. 149) to complete the desired effect.

It is possible to achieve more dramatic vignetting by using a negative that will print out with a very dark or black background.

Lith Negative

Lith is a term applied to film material which will reproduce original works in little more than black and white. It is commonly used in the copying of documents and art work and in the printing industry. A print with a full range of tones copied with lith film will have a very strong graphic quality as all mid-range tones are repressed.

Lith film has a very slow speed and consequently a restricted use in camera work. To obtain the striking and dramatic effects fully, it is more convenient to transfer the images obtained from more conventional films and papers onto lith film by either making intermediate transparencies or photocopying.

The photograph reproduced on pp. 80–81 is a print from a lith positive transparency which was made direct from a 35mm panchromatic back and white negative. The 35mm negative of a landscape was enlarged directly onto a sheet of 5×4in lith negative material and developed in a corresponding lith type developer. The film was held in a print easel in exactly the same way as a sheet of printing paper would be but all safelighting in the darkroom during the printing and development was red. To minimise back reflection it is best to place a sheet of black

Lith negative.
Print made from lith film exposed in the camera.
Carl Bernard.

paper under the film during exposure.

The resulting negative was then printed onto a sheet of 'hard' glossy-surfaced bromide paper in order to retain the high contrast achieved through the lith film process. The 'positive' print was a negative image but this helped to create a more dramatic contrast between the various picture elements. The print was finally sepia toned.

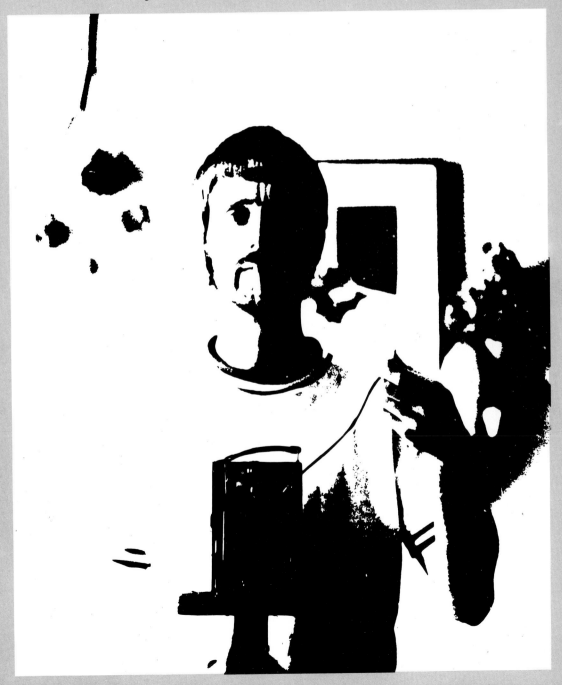

Masked Border

A masked border is a relatively easy way of making a line border surround to a print, emphasising the edge and consequently the pictorial element within the defined border. An image can be pictorially intensified by reducing its scale within the limitations of the overall paper format. Selective placing of the image by utilising the white or black surrounding area can be more successful than taking the picture to the extreme edge of the printing paper. In addition an image that lacks sufficient natural edge definition can be improved by introducing a fine line border.

The first stage is to select the negative to be printed and to decide upon the degree of enlargement. When this has been decided an aperture is cut from a piece of black card corresponding to that size. The photograph reproduced here was required to be $5 \times 3\frac{1}{2}$in (approximately the proportions of the original 35mm negative) and from a piece of black card measuring 10×8in an aperture of $5 \times 3\frac{1}{2}$in was cut. The central portion was removed and from it a 3/16in strip was trimmed from each of two adjoining sides. The outer frame mask was registered on top of a sheet of printing paper and positioned under the enlarger. With the safelight filter in position, the negative of the child was enlarged and positioned within the central open area. (If the exposure is not known, a test strip should be made at this stage.) The outer mask was then held in place by small lead weights positioned as near to the inner rectangle as possible. The safelight filter was then removed and the print exposure made. Without moving the mask or printing paper, the central portion of card was replaced and positioned so as to leave a gap of 3/32in all the way round and between the two pieces of card. This piece of card was then also held in place by more small lead weights at each corner.

The next and final printing stage was to remove the negative from the enlarger, replace the carrier and make an exposure of white light just sufficient to give a black. This exposure was made only on the paper exposed between the two sheets of masking card and, consequently, appeared black when developed. The masking card was then removed and the print developed, fixed, washed and dried in the conventional way. The width of the border line is worth considering; a line in excess of $\frac{1}{8}$in could have other implications

A further process for a border print is sepia toning. This has the effect of transforming all tone to sepia but the border, owing to its maximum black, will remain almost black.

Masked border.

Opposite: Only the outside mask is positioned for the first exposure. The second exposure is made with the enlarger light only and with the central mask (slightly smaller than the hole in the outer mask) in position. *Carl Bernard.*

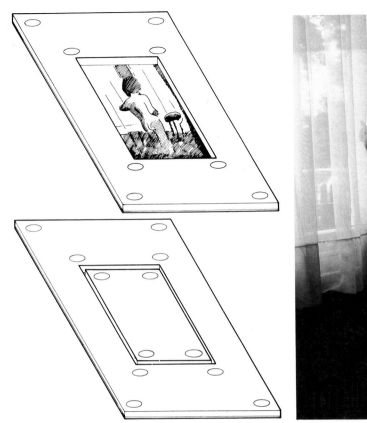

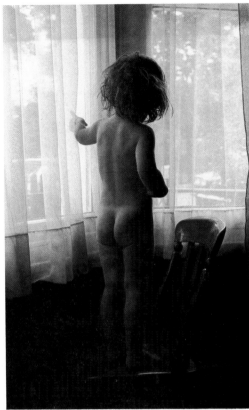

Bas-relief

Bas-relief is a relatively straightforward process that combines both positive and negative imagery. The results have a particular three dimensional quality which is peculiar to the technique.

The bas-relief print reproduced on p. 118 was from a negative and a positive transparency taken from a continuous tone black and white bromide print of a rock formation. The print was photocopied to obtain a 5×4in continuous tone negative, which was in turn contact printed using the same film stock to obtain the matched positive. Both negative and positive were placed emulsion to emulsion and bound together slightly out of register.

It is the degree of this mis-register that creates the bas-relief effect. (It also provides spaces around the edges for both negatives to be taped together.) Another factor which influences the result is the density of the positive used. It is desirable to make the positive slightly less dense than the negative and with

Bas-relief.
Continuous tone, positive and negative films were bound together slightly out of register and printed. *Carl Bernard.*

less contrast, otherwise the print will take on a negative bias.

The print was then made from the two 'bound' negatives in the same way as a normal print would be made from an enlarger. Ideally, a glass type negative carrier should be used to retain perfect contact and a flat plane between negative and positive.

The degree of enlargement is an added factor contributing to the final effect as the slight displacement within the two transparencies becomes more apparent in the print as the degree of enlargement increases.

Bas-reliefs are possible of course from smaller negative/positive sizes, but handling becomes much more difficult and the film stock is difficult to co-ordinate and less easy to control.

Bas-relief in Black and White

Bas-relief is a term used in photography for an almost three-dimensional effect. It is achieved by using two negatives: the original negative and another same-size film positive made from the original negative. The two are bound together, slightly out of register, and then printed conventionally.

The picture illustrated is an extension of the bas-relief process. The negative of the daisies was enlarged to 10×8in and an area of the image was chosen for the bas-relief treatment.

As the registration of the two negatives was important, Gravure Positive (a continuous tone sheet film which can be handled in red safelight) was chosen for the positive.

Using a red filter over the enlarger lens a piece of the 5×4in sheet film (Gravure Positive) was placed in contact with the chosen area of the projected daisy image under a sheet of glass. Test exposures were then made and the sheet of film processed normally. The most effective exposure was discovered by placing the test positive over the projected image. A slightly underexposed positive with lower overall density than that of the original negative was needed. A final positive was made. A 10×8in normal contrast bromide paper was then placed on the base board and, with the red filter over the enlarger lens, the negative of the daisies was projected onto the paper.

The processed positive was then positioned on the matching negative area but slightly out of register. A sheet of glass (larger than 10×8in) was laid on top to keep the positive and the paper in contact. After a test print, a final combination print of conventional and bas-relief images was made.

Montage 1

Montage is the piecing together of various images to make one. The technique can be used to create unrealistic and bizarre images but, in the photograph illustrated, montage was used to produce an interesting view from the otherwise empty bedroom window.

The bedroom itself was lit only from the window and had a monastic feel to it. Rather than ruin the interior lighting, the film was exposed using the meter reading for the interior at the expense of the brightly lit window area, which was consequently grossly overexposed. A light meter reading of the interior and one of the window area showed two f stops difference. The medium speed film was processed normally in a fine grain developer.

A range of exposures was made on a test strip print of the enlarged negative. Once processed the strip indicated that the window frame and its immediate surround needed three times as long an exposure as the rest of the print.

To make the print, the overall area was given an exposure suitable for the interior but the window area had to be 'printed in'.

By holding a piece of card with a small hole in it under the enlarger lens only the window area received more light. The mask was kept moving slightly during the extra exposure to avoid harsh, unnatural lines separating the 'printed in' part from the rest of the print.

When the print had been fixed, washed and dried, the still blank window panes were carefully cut out.

To make cutting up and retouching easier, single weight, matt surfaced bromide paper was used. Several prints were made in case of mistakes.

While the negative of the bedroom remained in the enlarger, the window edge was marked out in pencil on the masking frame. This negative was then replaced by another negative of a scene with a church in the middle distance. The image of the church had to be considerably enlarged so that it was slightly

Montage 1.
Photograph of a bedroom scene montaged with a view of a church. *Karen Norquay.*

bigger than the marked out area on the masking frame. The final print of the church was therefore very grainy and, because of underexposure in the enlarger, faint—ideal for the fake view out of the bedroom window.

Once processed, the print of the church was dry mounted onto a piece of card so as to be completely flat and the bedroom print laid on top of it. A piece of glass held the 'montage' in contact and it was photocopied onto continuous tone 5×4in film. Any size film can be used for photocopying, but the larger the negative produced the better the quality of print from it.

Montage 2

For surreal imagery, montage is ideal. The print illustrated here was made in a similar way to that of the bedroom photograph.

The film was given an exposure suitable for the interior. The long shutter speed necessary was just right to convey the movement of the cat. The camera was secured on a tripod. As the shutter opened, the cat dropped into the picture.

The exposure for the print was again calculated for the interior and the outline of the window.

The window panes were carefully cut out.

Another photograph was made of the cat looking through a window. Care was taken to capture just the right expression on the cat's face so that it would link in with the other photograph. The film was exposed for the window pane and the cat rather than the background. The cat was made quite small in the frame.

A fairly indistinct print of the cat's face was made to fit the size of the window and the mood in the principal print.

The images were combined and then re-photographed.

It is best to make a montage as large as possible before copying and then reduce it in the printing. If the montage is complex, a tracing of the main image should be used to facilitate the printing of the other images to the correct size.

Montage 2.
Opposite: Montage of a room interior and a cat looking through a window. *Karen Norquay*.

Montage 3

The combination of prints made from one original negative or transparency can produce a striking effect. The kaleidoscopic effect of the large lily pads was made from four enlargements of the same transparency (pp. 124–5). Two prints were made normally on Cibachrome paper and two more were made with the transparency the wrong way round in the carrier. Print quality had to be exactly the same in each print. The four prints were then mounted together. By re-photographing the pattern and repeating the process above, an intricate detailed pattern can be built up which would appear abstract at first glance.

A chess-board effect can be achieved by combining negative and positive images from the same original and printing them in the same way as above.

The variations on this theme are endless but simple striking images should be used. It is important to remember that making patterns out of an inferior image will not make it any more interesting.

Montage 3.
Overleaf: Montage of four identical prints to make a pattern. *Karen Norquay*.

Moiré

Moiré is the interference pattern observed when one screen formation crosses another similar one. It can occur, for example, when an Autoscreen negative is made from an existing screened halftone reproduction or when the screened image on a photo-stencil crosses with the ruling in the nylon of a silk screen. The moiré effect was used for the landscape photograph in an attempt to exaggerate a feeling of windblown and tumbling confusion in the foreground grasses.

The original photograph was recorded on black and white panchromatic roll film with a red filter which increased the contrast between the yellow grasses, white clouds and blue sky. A 10×8in print was made on a medium grade printing paper from the most suitably exposed negative. Two negatives were then made from this print, one on lith and one on Autoscreen film. One sheet of each was loaded into a 5×4in double-dark slide and the print was photocopied. The two negatives were then processed normally, according to their individual requirements. The next stage was to sandwich the two negatives together and rotate them separately until the image structure on

Moiré.
The pattern produced by moiréd screen formations can give interesting effects. *Carl Bernard.*

the ordinary film emulsion moiréd with the Autoscreen negative. The two negatives were then taped together along the misaligned film edges. The combined negatives were finally printed in a 5×4in enlarger. A small aperture was selected in the enlarger lens in order to counteract the slight lack of contact between the two emulsion layers of the films. A similar effect to that of Autoscreen film can be achieved by printing onto lith film through a halftone screen.

The degree of the moiré effect is controlled by the angle of displacement of the two image screen formations. It is, therefore, important to consider the actual degree of displacement between both elements to ensure that the image is still recognisable.

Photogram

Simple photograms are made by arranging objects on a sheet of light sensitive paper in the darkroom and then exposing it to white light to produce white shapes against black.

If the objects are flat they can be laid out on a glass negative carrier and enlarged in the darkroom. This process is particularly interesting when small objects are enlarged and large objects reduced.

For the picture on p. 128 the leaves were arranged in a circle and sandwiched in a 10×8in glass carrier. The lens of the enlarger was stopped down to give maximum depth of field. The image was reduced to 5×4in on the baseboard of the enlarger and exposed onto a sheet of 5×4in lith film.

Instead of processing the film conventionally in lith developer, it was given a very short development of one minute in print developer to bring up the tones in the leaves while still retaining some contrast. (Deep red safelights had to be used throughout.)

This positive transparency was then contact printed onto another sheet of lith film which was processed in the same way as the first. The negative produced had leaves on a clear background which, if printed, would come out black.

The photograph of the old woman was taken with a 35mm camera and a black and white print made. It was re-photographed onto 5×4in lith film and this too was processed in print developer to retain some of the tones. The result was a background of clear film with a negative image of the old woman in the centre.

The negatives of both the photogram and the old woman

were sandwiched and contact printed together on bromide printing paper.

Once fixed and washed, the old woman and all the black areas on the print were blanked out with masking fluid. When the print was sepia toned only the leaves were affected.

Photogram.
Photogram of leaves sandwiched with a lith negative (*bottom right*) and prints from the intermediate stages of the process. *Karen Norquay.*

Photograms on Cibachrome Paper

The photogram dates back to the very beginning of photography. It is a simple way of making a print of, say, pressed flowers and leaves without using a camera. Instead of white images on black as in the usual photogram, Cibachrome

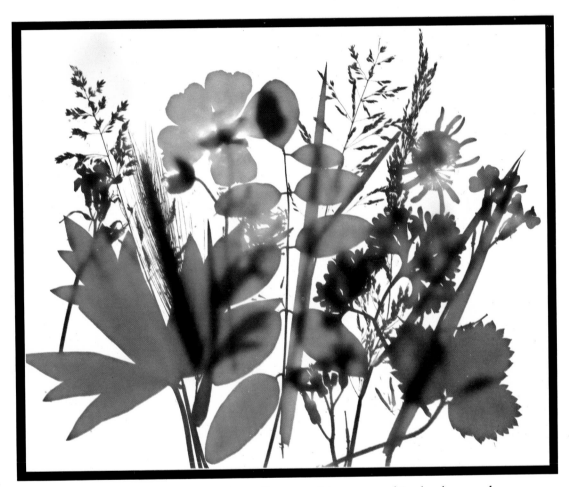

paper permits a direct positive on a white background.

Colourful translucent and semi-translucent materials should be used for photograms on Cibachrome paper. A choice of almost equal density materials is important. Objects can be arranged directly on a sheet of Cibachrome paper while under the enlarger but even with a Wratten No 10 safelight 5ft away one has only about 1½min to arrange them before fogging occurs. As it takes about that time for the human eye to become accustomed to the faint light, this method seems unsatisfactory.

To get the effect in this picture, the flowers and leaves had to be pressed down to keep them sufficiently in contact with the paper but, since the sap in the leaves would have stained the

paper, the flowers were arranged and sandwiched between two sheets of glass and the edges taped together. The items could therefore be arranged in daylight and positioned on the Cibachrome paper in complete darkness without the danger of safelight fogging.

In the present case the enlarger was adjusted so that the light from the lens covered an area 10×8in on the masking frame beneath it.

In total darkness the sandwiched flowers and leaves were placed in contact with a test strip on the masking frame. Even though there was no transparency in the enlarger, the filtration guide on the back of the pack of paper was followed.

Exposure and processing were normal and only an evaluation of the exposure from the dried test strip was needed. A 10×8in sheet of paper was then placed in the masking frame and the sandwiched flowers laid on top. The desired exposure was given and the final print then processed in the normal fashion.

Chemical Contamination

Negatives or prints that are intentionally or otherwise wrongly processed, chemically contaminated or maltreated in one way or another can, by discriminating selection, provide sources of interesting and unusual imagery. Prints discarded at various stages of processing can sometimes develop changes in image structure that only become apparent when retrieved some time later. Partial tone reversal and chemical staining can occur when prints that are developed but not properly fixed are exposed to an unsafe light source, and a rummage through the darkroom waste bin at the end of a working day will occasionally reveal image material with unusual visual effects that could be reproduced deliberately.

The negative/positive used to make the print produced here was discarded during development because of surface scratches across the emulsion. The negative was dropped from the developer into the sink surround. After a few hours, several intermittent flashes of white light and numerous splashes from stop bath water, fix and developer, the negative was retrieved and found to contain some interesting image changes. Although a great deal of the image had been obliterated, sufficient remained to produce a still recognisable form. The negative/ positive was printed on a soft grade of paper to reproduce the very subtle tones that had appeared during its period in the darkroom sink.

Chemical contamination. A print on soft paper from a negative that was rejected after development and subsequently exposed to light, stop bath water and fixer. *Carl Bernard.*

130

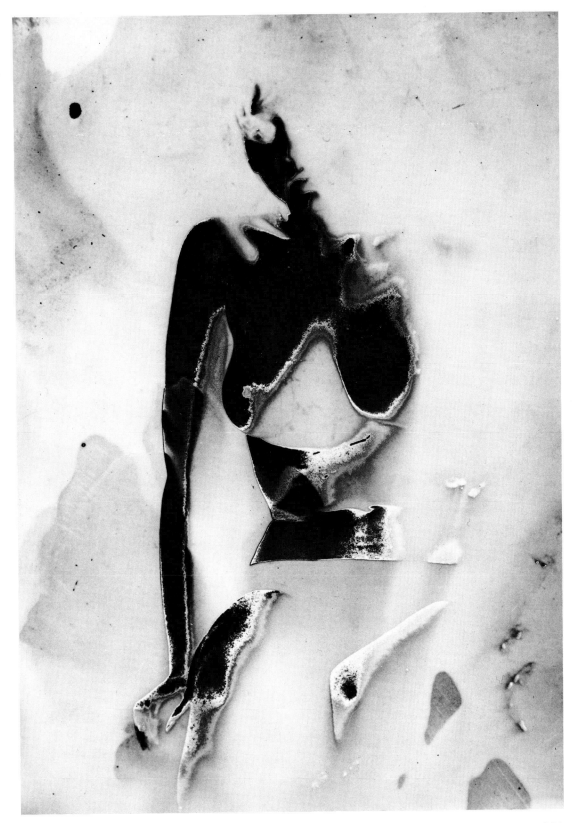

4
The Studio Workshop

Introduction

Adequate studio space with proper technical and craft equipment is essential if one is to extend the conventional and formal reproduction of photographs. For all film work, whether retouching, combining two or more images, masking or straightforward analysing, a light-box makes life easier and the results more satisfactory. For trimming prints, control and accuracy are best achieved with a steel staight-edge and a sharp trimming knife. Rotary trimmers, however, offer a reliable and safer alternative.

There is an almost unlimited choice of materials for colouring negatives or prints. Water-based colours allow some degree of change but suitable combinations are a matter of personal choice, or trial and error. There are many subtly surfaced types of photographic printing paper, each having different qualities which determine the most suitable colouring method. For example, coloured lead pencils, ideal for matt-surface papers, are ineffective on glossy or resin-coated papers.

All prints that are to be coloured or generally worked upon are that much better for having been stretch-dried. The wet print is laid on a clean board, and its edges are taped down with brown sticky tape that has been softened by prior wetting. Overnight drying will stretch the paper print to create a tight, flat surface that will not crinkle during or after the application of ink or paint.

There is a wide choice of adhesive agents for mounting prints: Cow-gum, spray mount, dry-mounting and double-sided tapes are all satisfactory. Dry-mounting is permanent, and double-sided tape and spray-mount are not easily removed. Overall, Cow-gum is the most successful, but it is not recommended for print sizes larger than 10×8in. The area surrounding a print is just as important as the image itself and should not be arbitrary or ill-considered. The margins should be proportional and complimentary to the image.

Contrary to many opinions, there are very few prints that can be improved by cropping or manipulation of the image. An original composition is exactly that and unique to the photographer. It is arguably justifiable to exaggerate an existing image to convey more fully an original emotion or impression, but never to distort the truth with intentional omission or calculated composition, unless, of course, a completely abstract image is intended.

C. B.

Colour Separation on One Transparency

Colour films consist of three emulsion layers. The top emulsion is sensitive to blue light, the second to blue and green and the third to red.

When colour photography first came in, it was necessary to make three separate exposures (one for blue, one for green and one for red light) on black and white sensitive material. Once processed, each negative was dyed and then the three were combined to make the full colour picture. A process similar to this and called 'dye transfer' is still used today to make colour prints from black and white negatives. It is a process which, when experimented with, can produce strange colour effects from ordinary black and white images.

To make the picture illustrated on pp. 132–133, however, the only filters used were those recommended to make colour separation negatives for dye transfer.

If blue light is not permitted to affect the emulsion of a colour transparency, the final image will be yellow in colour since it has only been exposed to red and green light.

Three exposures were made on the same frame of a transparency film, using a different Wratten gelatin colour separation filter for each. For three exposures on one transparency without camera shake, the camera had to be extremely rigid on a tripod.

Using the manufacturer's recommended ASA film speed, a general light meter reading was taken. The f stop and shutter speed indicated were used to make the three exposures on the same frame of the colour transparency film.

A denser colour filter than that recommended for one of the separations will lead to interesting colour casts.

Photoengraving

Photoengraving does not involve manual working on a plate with engraving tools but solely the action of acid on a metal plate. A light-sensitive acid resist is used to protect parts of the metal from the effects of the acid. If a positive film image is used at the plate-making stage the process is termed intaglio (ie from the depth of the metal). Photography has become an integral part of print-making; it is a versatile element that can be manipulated to suit the varying requirements of the artist. It is a process that requires no specialist skills other than a selective eye and a systematic approach.

The first stage is to prepare a positive, same-size film transparency that is a reverse mirror image of the original. The positive must be of very high contrast and it may be necessary to transform a continuous tone original into line via a lith process.

The positive for the photoengraving of the dragonfly was printed directly from a continuous tone 35mm negative onto a sheet of lith film. This gave a positive image of high contrast and the size required for the engraved plate. There was no need to reverse the image as a dragonfly's body is virtually the same, whether viewed 'real' or 'mirrored'.

The next stage was to transfer the dragonfly image onto the surface of a copper plate. The plate was first thoroughly cleaned and then coated with a light-sensitive emulsion. When dry, the sensitised plate, in contact with the positive transparency, was exposed to ultraviolet light in a vacuum light-box. The ultraviolet light hardened the exposed areas of the plate and made them insoluble while the unexposed areas remained soluble. When the exposure was completed, the plate was removed from the light-box and gently sprayed with cold water to remove all the unexposed soluble emulsion from the plate surface. Before being etched, the copper plate was 'stopped out' in all areas that were not required to be acid etched, ie the plate back and edges. For this process, straw hat varnish was applied with a brush.

The plate was then placed in a bath of Dutch Mordant and etched until sufficient depth had been achieved for the inking and printing stages. The etched plate was then thoroughly cleaned of all emulsion and straw hat varnish and polished before the inking up. Inking was carried out by 'pushing' coloured inks into the 'open' areas of the etched plate by using small pieces of stiff card. The plate was intermittently heated to allow the inks to flow more freely. All excess ink was then removed from the plate surface by gently brushing with tissue paper.

The final stage was to print the inked plate onto hand-made unglazed paper using a copper plate etching press. The printed photoengraved image was later extended on to the surrounding paper surface by adding coloured pencil drawing to the dragonfly wing.

The whole process of photoengraving has only been very basically and briefly described here. Anyone contemplating this process as a means of printmaking should make an in-depth study of the overall process to ensure satisfactory and acceptable results.

Photoengraving. Copper etching printed onto hand-made paper. The image has been extended with coloured pencil. *Carl Bernard.*

Hand-drawn Negative

Hand drawn negatives can be produced in many ways and with materials in common everyday use.

Glass and clear acetate are the ideal base materials for use in an enlarger because relatively small pieces can be used. The image making marks can be applied by pen or brush and virtually any translucent or opaque medium. If prints are to be made by contact printing the hand drawn negative, the original negative art work will naturally have to be the same size as the required print, but this does allow alternative base materials to be used such as tracing paper or airmail type lightweight papers.

The permutations of negative base material and the medium used to make the image are endless and impossible to categorise. No one arrangement can be said to be the best and it is, therefore, open to personal choice and experimentation as to what techniques to use. Ability and skill in the creation of realistic imagery are other determining factors in the choice of subject matter.

The example reproduced here was drawn with brush, pen and indian ink on a piece of clear acetate measuring 5×4in. A print was made from the negative using an enlarger in the same way as a normal print would be made from any conventional negative. All prints originating from this method will reproduce with reversed tones and the contrast will be controlled by the grade of printing paper used.

Hand drawn negatives, like photograms (see p. 127), can be derived from the most unlikely sources, eg spray paints, offsetting with ink from textured surfaces and, in fact, any medium that can be applied as a 'flat' translucent or opaque mark upon a translucent or transparent base material, for example discarded film stock. The use of different grades of printing paper, from soft to very hard, will give alternative renditions of contrast and can be chosen to give the desired graphic quality.

Partial bleaching of a print is another way of obtaining a hand drawn image (p. 140) and provides a more accurate way of reproducing an alternative to the photographic original. Oil, lead or wax based medium is applied to the surface of a black and white print that contains a more or less full range of tones.

The print surface is applied with the medium, gradually covering the underlying photographic image, painting or drawing over the areas that are to be portrayed in the finished print. The print is then bleached so that only the applied image remains.

Hand-drawn negative. Print from an image made with brush, pen and Indian ink on clear acetate. *Carl Bernard.*

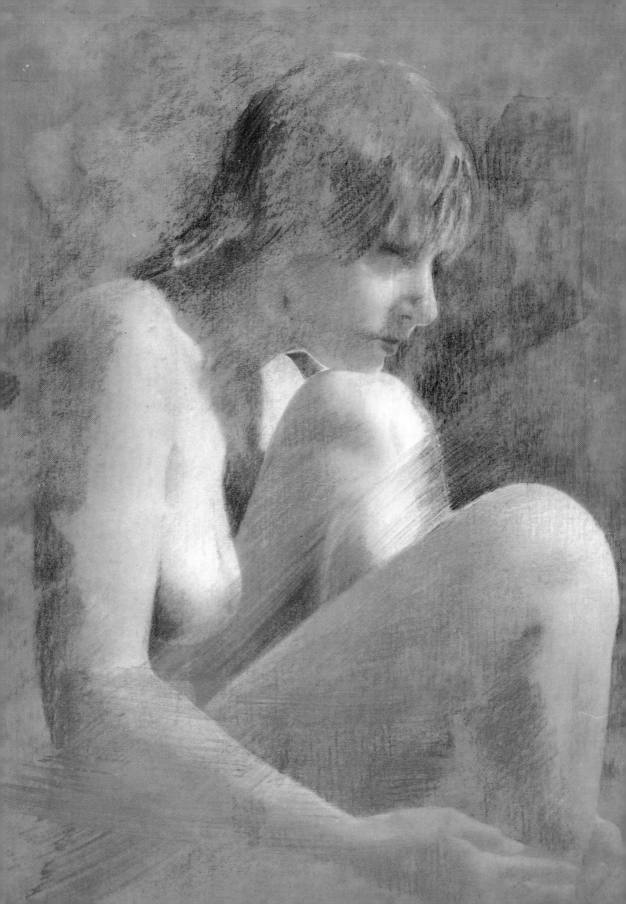

Isolated Colour

Most chlorobromide papers are similar in speed to bromide papers. They have a fine characteristic curve of tone separation. By partially developing this paper, warm tones can be achieved. These papers, and some bromide papers, come in varying tones of cream base.

The ballet dancers were photographed at Covent Garden. The set design dwarfed the dancers and to isolate them even more a hint of colour was added to their costumes. The rest of the print was left black and white. Care was taken to avoid the trap of overdoing the colour and thus spoiling a powerful image. As the stage lighting was very exaggerated a soft bromide printing paper was used to yield details in the highlights.

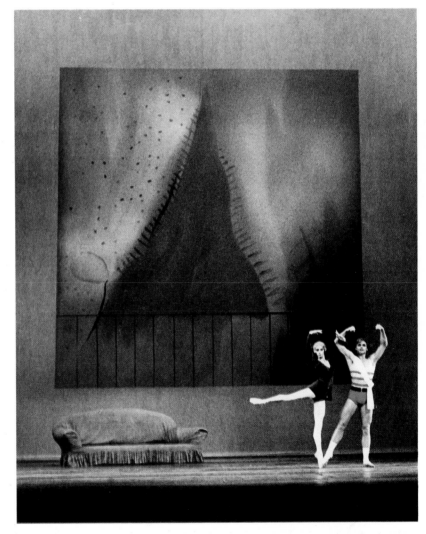

Hand-drawn image.
Left: a black and white photograph, hand-painted and then bleached to leave only the painted image. *Carl Bernard.*

Isolated colour.
Right: a black and white print partly coloured by hand. *Karen Norquay.*

Drawing and Photo Image

As an alternative to colouring a photograph within the confines of the printed image, it is sometimes desirable to extend that image onto the surrounding print area. The print has to be made smaller than the overall paper size so the negative is exposed onto the printing paper through a rectangle cut from a piece of black card.

The photograph here was originally printed from the whole of a 35mm negative but centralised within a sheet of 10×8in glossy bromide paper at a size of approximately 6×4in. The leaves that were 'cut off' around the edges were then extended into the surrounding white border area by using grey and black fibre tip pens.

The scale and overall quality of the image was quite important to the style and choice of pen used. A picture comprised of fine detail or a greater range of tones would have required an entirely different approach and a different paper surface would have been required. For drawing on a print, a matt surface provides a much better 'key' for additional pencil or crayon work.

Drawing and photo image.
Print from a 35mm negative extended by drawing with fibre tip pens. *Carl Bernard*.

Selective Colouring

Selective colouring is a method of applying dye or ink to the surface of a black and white bromide print. It is a way of distributing more than one colour and allows for more than one colour to be used.

The dragonfly wing (p. 144) was originally photographed on a sheet of glass and against the sky. This method of back-lighting was used in order to define the sophisticated wing structure. A 35mm single lens reflex camera with a macro lens enabled focusing down to 4in and, consequently, filled the entire 24×36mm film frame.

The film was developed according to manufacturer's instructions in a universal type developer.

A bromide print was then made on a high contrast black and white paper to a size of 5×4in. This relatively small enlargement, coupled with the high contrast paper, contributed to the quality required in the finished print. The print was then ready for colouring.

A piece of cotton wool was rolled up into a ball about the size of a small grape and dipped in a mixture of rubber gum solution diluted with petroleum spirit. This was then dabbed onto the print surface in a random pattern that effectively masked off about half of the image area.

The print was then immersed in a tray of red water-based ink until sufficient colouring had been absorbed into the print surface. All excess ink was then removed with blotting paper and the gum solution was gently rubbed away. The areas that were now red had gum solution applied in the same manner as before, ie the print was masked-off in *all* but the *undyed* areas. The overlapping caused by the imprecise masking method was a calculated effect.

The difference between precise masking and a random effect can be controlled by the way the masking solution is applied (see Selective Toning, p. 144).

The immersion procedure was repeated using a tray of blue ink. After removing the masking gum solution once again, the print was finally washed in running water until enough of the red and blue dyes were removed to achieve a pale, gently washed quality. After removing excess water with blotting paper, the print was finally dried out and mounted.

When colouring prints, it is advisable to build up the colour gradually. The application of too much ink or dye can cause problems if one colour is too 'strong' and needs to be reduced.

Selective Toning

Selecting toning is a method of controlling the colouring of a print by masking out particular areas. When fine detail is required the masking fluid can be applied with artist's brushes.

The photograph of a dead bird on beach pebbles was printed onto a glossy surfaced bromide paper from a 35mm continuous tone negative. The print was processed in the normal way but not glazed. The smooth surface of the unglazed print meant that the masking fluid could be applied to the detailed areas more accurately. The masking fluid was prepared in the same way as previously described in Selective Colouring

Selective colouring.
Top and far left: dilute gum solution was applied to a print and the combination immersed in a tray of red ink. After removing the first and washing, a second gum solution was applied to the now red areas and the print immersed in blue ink. Extended washing produced the pale colours. *Carl Bernard.*

Selective toning.
Near left: careful masking of the bird enabled the stones only to be sepia toned. *Carl Bernard.*

but this time a No. 2 paint brush was used. The entire image of the dead bird was masked out and the solution was allowed to dry before sepia toning (see p. 149). After removing excess water from the surface of the washed print, the masking fluid was carefully rubbed away from the surface and the print dried.

The same method of masking can be used to apply coloured inks or dyes as an alternative to sepia toning.

Toned Print

The photograph of the sea was taken on a dull overcast day. The general effect was cold and menacing. In order to accentuate this, the picture was made grainy and a cold blue.

The photograph was taken with a 35mm camera and 135mm telephoto lens. This lens compressed the perspective so that everything appeared to be in a single plane. There was no need for a tripod: the fast shutter speed of 1/250sec combatted

Toned print.
A grainy print, bleached and toned blue after processing. *Karen Norquay.*

camera shake. The longer the telephoto lens, the faster the minimum shutter speed for hand-held shots: 1/125sec for 135mm lens, 1/250sec for 200mm lens etc.

A fast film enabled a fast shutter speed to be used and gave the required grain (see p. 66). The film was developed normally in a universal type developer and the image printed on a hard grade of printing paper to accentuate the overall grain. The final print was fixed, washed thoroughly and toned blue.

Toning is a chemical after-treatment. The print is bleached, washed to remove excess bleach, re-developed in chemical toner, washed thoroughly and dried. Sepia toning (see p. 149) is the most common toning treatment but it is possible to buy proprietary brands offering a selection of colours.

Hand-made Negative

The line image was made by applying black poster paint to a
piece of clear acetate followed by force drying in a very hot
drying cabinet. The accelerated drying process caused the

Hand-made negative.
Negative made by force
drying poster paint on
clear acetate and printing
onto high-contrast-paper.
Carl Bernard.

emulsion to crack and peel away from the acetate surface. The
piece of acetate was then cut down to 2^1_4in square and used as
a negative for enlargement and printing on a high contrast
grade of paper. The print was subsequently photocopied onto
5×4in lith film and developed accordingly.

Two prints were made from the high contrast lith negative: one from the negative the correct way round, ie emulsion side downwards, and one with the negative turned upside down, ie emulsion side upwards. Consequently, the second print was a mirror image of the first. The final stage was to butt up the two matching edges of the two prints and mount them together.

Hand-coloured Print

A black and white bromide print was used as the base for this hand coloured image.

It was important to have a print which was very sharp and had a full range of tones from rich blacks to clear white areas.

Spirit based markers were used to colour the print surface owing to their vibrancy and colour range.

The effectiveness of the final result owed much to the graphic contrast between the black and white areas of the underlying photograph and the applied colour. The original garden scene was appropriate to the technique used but virtually any black and white print can be coloured in an original way by experimenting with various colouring mediums.

Hand-coloured Negative

The colour photograph illustrated here is not a print from a conventional colour negative or a reversal print from a transparency; it is a print originating from a hand coloured 5×4in black and white continuous tone negative.

A 10×4in bromide print was copied onto a sheet of 5×4in ordinary (blue sensitive) film and processed in the normal way. The negative was then hand coloured with inks normally used for retouching colour prints. The colours used were predominantly orange, yellow and red, and were applied with an artist's sable-hair brush. After the first colour had been painted onto the emulsion surface, the film was rinsed under a tap and re-dried. This caused the ink to flow across the film surface and create a thin overall colour. The other inks were then applied to more localised areas and the film was dried. Next a colour print was made from the 5×4in negative. This required no special calculation or filtration; the most important factor was the effect of applying colour to a black and white negative. Finally two slim vertical tapered strips were cut from the print. The remaining three print sections were then butted together on a black background.

148

Sepia Tone

Black and white prints can be toned various colours but not many are as permanent as sepia toning. A two bath (bleach and toner) method was used to produce the print shown here. Two separate solutions are required for the process. The print to be treated must always be thoroughly washed after the usual development and fixing. The print is placed in the bleach solution and gently rocked until the black image changes to a pale yellow colour. It is washed once again to remove any traces of bleach and then placed in the toning solution and rocked gently until it acquires the sepia tone. The print must again be

thoroughly washed before drying to complete the process.

This method of toning can produce various qualities ranging from cold to very warm sepias; a contrasty and hard print will produce a colder, richer colour whereas a soft original will tone into warmer colours. The final colour also depends on the type and make of paper; various types can be tried.

The solutions are made up as follows:

Stock bleach solution: Potassium ferricyanide 25g
 Potassium bromide 25g
 Water to make up to 250ml
(For use: 25ml of stock solution, made up to 250ml with water.)

Stock toning solution: Sodium sulphide 12.5g
 Water to make up to 250ml
(For use: 25ml of stock solution, made up to 250ml with water.)

It is advisable to store bleach solution in the dark; the toner should only be used as a 'one-shot' process.

As stated earlier, it is essential that all prints are thoroughly washed before sepia toning. Any contamination with fixer, either from washing bath or fingers, will stain the print surface. The process must be carried out in a well ventilated area.

The bleach solution alone can sometimes provide interesting qualities of 'colour' in a print that has been greatly overexposed. It will leave areas of a pale yellow-ochre, albeit rather uneven in appearance, occasionally resembling late nineteenth-century photographic works that have 'aged' through time. Very dark areas can be partially bleached out by controlling the process.

The photograph shown on p. 149 is a reproduction of a continuous tone black and white print that has been photocopied using lith film as an internegative. The lith film has 'dropped out' all intermediate tones and the negative, when printed, is a positive image with a stark and 'gritty' quality. Experience of the reproduction characteristics of lith film can be helpful when converting a tonal image into black and white. Lith film will not reproduce grey tones as grey, only as black or white. It is generally more acceptable to start with an original print that contains quite clearly defined areas of contrast, otherwise the lith internegative will produce a print with extensive 'filling in' and a disappointing loss of image structure and form.

Electrophotographic Copying

Electrophotographic copying has been around for years and is commonplace in offices and general industry. In the last few years technologists and artists have been trying to exploit its potential.

The recent colour copying machines are now competing with standard colour printing. The result is still somewhat inferior but much cheaper. If an exact colour copy is wanted, commercial colour printers are the answer but, if experimentation with colour and black and white is the objective, there seems to be no limit to the effects attainable.

Because of their popularity, there is a profusion of machines for black and white photocopying on the market but not so many colour ones. There are two versions of the electrophotographic process – one using plain paper, the other using coated paper. Copying onto plain paper is the original xerography developed by the Xerox organisation, although there are other manufacturers in the field now. The other version is known as Electrofax. In this the copy is formed on the zinc oxide surface of the paper itself. The advantage of this is that each copy is similar to a lithographic plate and can be used like one, to obtain hundreds of copies on a small offset machine. The copy, however, has a shiny, rather sticky finish to it. The xerographic machine seems to be the most versatile of the two and the examples illustrated were all done on such a machine.

The way in which black and white xerography works is:

1. The surface of a selenium-coated drum is sensitised by an electrically charged grid which moves across it. The drum thus has a positive full charge. If kept in the dark, selenium will retain this charge.

2. Moving lamps illuminate and scan the original and the image is projected onto the selenium surface. The positive charge disappears from the areas of the drum which were exposed to light, ie the white areas of the original. The black or printed areas of the original, being dark, reflect little light onto the drum so the charge is held there.

3. Negatively charged carbon powder is dusted over the drum and sticks to the positively charged image.

4. A sheet of paper is brought into contact with the drum and by means of a further positive charge beneath the paper

attracts the powder from the drum to the paper, thus forming a direct positive image.

5. The powder is then fixed onto the paper by heat to make a permanent image.

Carbon is a very stable substance offering great stability to the copy. The whole process, from start to finish, takes seconds.

Electrophotographic copying.
Direct copy of leaves on colour copier. *Karen Norquay.*

Black and White Xerography

Direct positive photograms using Cibachrome paper have already been described (p. 129). These are produced by light travelling through translucent materials leaving dense objects to come out in silhouette. Nothing can beat xerography for instant contact prints!

Black and white xerography.
Above and overleaf: two ways of arranging flowers on a copier: pressed between glass, or placed directly on the copier glass. *Karen Norquay*.

Three-dimensional objects can be placed on the document glass and photocopied. Normal objects assume new dimensions. If taken directly from the human body or plant life, detailed surface textures not immediately visible to the eye are picked up by the machine. Whole pictures can be made up with feathers, sliced fruit, vegetables, leaves, flowers—in fact anything that is not too thick or bulky and has interesting surface detail. A direct copy of plant life looks very much like an etching of the same subject.

When making these direct contacts care must be taken to ensure that the document glass is free of fluff and dust, for these will also be recorded on the white background.

The process of course is ideal for photomontage. The montage can be made up on the document glass and the result seen almost instantly and any adjustments needed made. If the photocopier operator is not keen on things being put down directly on the document glass, the composition may be arranged on a piece of glass and then transferred to the machine. In the case of the photograph here, the plants were sandwiched between two sheets of glass which were taped together to stop them moving around.

It is possible to photocopy onto kinds of paper other than that designed for the photocopier if the paper is equal in size and thickness to the normal paper used. The machine will reject anything thicker or thinner.

Colour xerography machines will make positive transparencies, from originals, on acetate. In black and white xerography machines tracing paper can be used. This positive can then be used to make a photo-silkscreen, an etching or a lithograph.

To make the landscape shown above, a piece of tracing paper was placed on top of the pack of paper in the paper tray

Black and white xerography.
Above: landscape print photocopied onto tracing paper, contact printed onto soft bromide paper and sepia toned. *Karen Norquay.*
Right: repeated photocopying of black and white print (inset) produced a broken image, which was contact printed onto paper with a blue base. *Karen Norquay.*

of a black and white xerography machine. A monochrome print of the landscape was laid on the document glass of the machine and a photocopy was made onto tracing paper. This positive image was contact printed onto a soft grade (grade 2) of bromide printing paper. The result was a black and white negative print of the landscape which was then sepia toned.

The effect was quite startling. When using tracing paper in xerography the image may not be totally permanent and should be handled carefully.

An after-treatment which fuses the image with acetate is available on Xerox machines. Photocopies made on acetate can be used as overlays in graphic design.

A straight Xerox made from an ordinary black and white tonal photograph appears slightly more grainy and contrasty than the original. When that Xerox is photocopied again, the tones tend to separate out. If the process is repeated, the blacks break up completely and the very light tones become totally white. The effect is similar to distortion on a television screen.

An original black and white photograph was photocopied and the photocopy in turn photocopied, and so on, to find out how far the abstraction could meaningfully go. When a suitable stage was reached – the sixth photocopy – the process was repeated again but this time onto tracing paper (see p. 156). This image was then contact printed onto a sheet of photographic printing paper which had a special blue base. The result was a negative, almost abstract image on a blue background (see p. 157).

Light sensitive bromide paper can be bought with a coloured base instead of the conventional white or cream base. In fact, there is a rainbow pack on the market – a box containing five different colours in packs of 10. The disadvantage of this paper is that it only comes in one grade which limits the final print quality.

The same result, though, can be achieved by immersing a normal black and white bromide print made on any grade of paper in an appropriately coloured dye until it takes on the required density of colour. After the excess dye has been taken off by pressing the print between two sheets of blotting paper, the print can be stretched out to dry.

There is a stage when there will be no appreciable difference between a photocopy and what it has been copied from. This is when all the pure blacks and tones have separated out completely and the copy is made up of tiny black lines. The more contrasty the print the more linear the photocopy.

The nude was lit with a very strong spotlight from the side.

Black and white
xerography.
Repeated photocopying
broke up the image,
which was then contact
printed and sepia toned.
Karen Norquay.

The original print made from a 35mm negative was extremely contrasty. The photocopy was photocopied in stages until the image break-up had stopped. The final effect was very linear.

The size of a photocopy is limited by the size of the original and the size of the document glass on the xerography machine. The machine generally only makes same-size copies. The minimum size is approximately $8\frac{1}{2} \times 13\frac{3}{4}$in, the most common size of paper used being A4. These limitations are frustrating but, especially when working with black and white photocopies, the effect can be continued by re-photographing the copy onto a negative which in turn can be printed at whatever size is wished. Experimentation can be continued using darkroom techniques.

To emphasise the linear effect on the last photocopy of the nude it was re-photographed onto a sheet of 5×4in lith film. In the darkroom a faint, slightly fogged print was made on a soft grade of bromide paper by overexposure and underdevelopment.

After the print had been fixed and washed thoroughly it was given warm, brown tones by toner bleaching and immersion in exhausted sepia toner. The result resembled a soft pencil drawing on a cream background.

Colour Xerography

A colour copier works in a similar way to a black and white one. Instead of carbon, coloured powder (called toner) is deposited on the drum. This comes from three separate dispensers, each with a different coloured toner powder— yellow, magenta and cyan.

Again moving lamps scan the document glass illuminating the original. The image is projected onto a mirror and focused by a lens. As the light leaves the lens it passes through a coloured filter (the colour of which depends on the colours or colour the machine has been set up for). The image is reflected onto another mirror and then onto a drum which, as in black and white xerography, is light sensitive. The exposed drum surface revolves (either once, twice or three times, depending on how many colours are wanted) to receive toner from the appropriate dispensers. The powdered image is then transferred from the drum to the copy paper and fixed by heat.

When a colour copy is being made, moving lamps scan the document glass three times, firstly to pick up the magenta part of the image, secondly the yellow and lastly the cyan. A black

and white print was laid down on the document glass and the multi-colour button pressed. The print was scanned once, which laid down a magenta image on the paper. The print was quickly removed from the document glass and the second scan was made. The sheet of paper in the machine was thus coloured yellow overall. The original print was then replaced, slightly out of register, to receive the third scan for cyan. Where all three colours have registered, a black image is formed. (See pp. 161–162.)

The colour photocopies illustrated here have all been made on the extremely versatile 6500 colour Xerox copier.

There are four colour selection buttons on this machine; one is for multi-colour copies while the others control the three basic colours, yellow, magenta and cyan. To make a colour copy from a flat, full colour original only the multi-colour button need be used. This also applies to making black and white copies from black and white originals on this machine. When the colour original is made up of only one or two colours then the corresponding buttons should be pressed. This six colour option also applies to colour toning of a black and white original.

Another set of yellow, magenta and cyan dials control the colour balance of a colour photocopy and can lighten or darken one colour.

The magenta and cyan colour selection buttons were pressed to make a blue photocopy of a black and white print (p. 164). As a dark blue was wanted the magenta and cyan colour adjustment dials were set to darken the colour. The effect is similar to sepia toning and other types of chemical colour toning of bromide prints but the method is much quicker, less messy and offers a wider selection of colour which can be adjusted at the touch of a dial. Some purists, however, might not like the mechanical feel to a toned photocopy.

Colour xerography.
Previous spread: the magenta and cyan scans of a black and white print were made slightly out of register. The yellow scan was made with print removed. *Karen Norquay.*

Following spread, left: colour copy of black and white print made with the cyan and magenta controls turned up full. *Karen Norquay.*

Colour Xerography with Slides

A slide adaptor used with the 6500 machine allows production of enlarged copies directly from 35mm slides. A carousel projector fitted onto the side of the Xerox machine projects the slide image onto a mirror which then reflects it onto the document glass. The projector is fitted with zoom lenses which will produce a range of image sizes from approximately $4\frac{1}{2}\times7$in to $7\times10\frac{1}{2}$in. The slide adaptor has an image brightness control

Colour xerography with slides.
Following spread, right: colour copy of a transparency projected onto the photocopier glass. Note the effect of the hot spot. *Karen Norquay.*

to compensate for underexposed or overexposed transparencies.

Contact prints of slides up to 10×8in can be made by placing them directly on the document glass.

The result from a colour copier will never be the same as a colour print made by a professional printer on colour sensitive paper, but the cost will be much less.

A transparency which has been exposed to give a good variation of light and dark tones will photocopy well. An image on a transparency that is either flat or contrasty will become even more so, but slight underexposure or overexposure can be compensated for.

Once its limitations are understood, a colour copier can become an important tool in photography.

A colour photocopy was ideal for the photograph of the girl illustrated here. The silk screen effect heightened the texture of the girl's skin and the wallpaper behind her. Some colour copier machines have a hot spot in the middle of the scan. Here the spot was used to advantage to give the effect of colours intensifying around the edges.

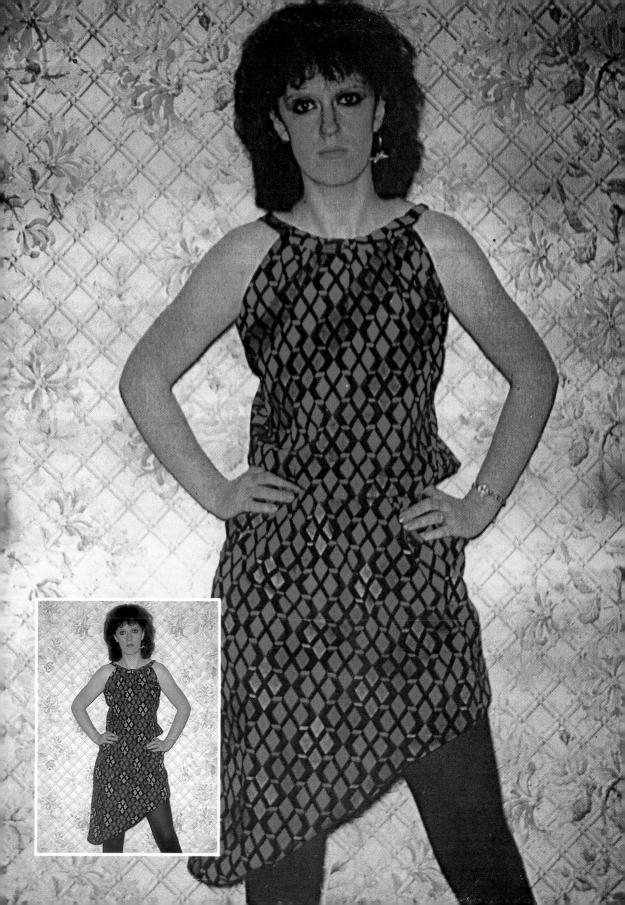

Afterword

It seems to me that photography now suffers from two sizable misassumptions, made by photographers, intending photographers and the general public alike. Photography is regarded as an entirely 'transparent' medium, fitting the most straightforward kind of reportage which anybody can do; or the camera is thought to be (if worth thinking about at all) an instrument of 'high art', the use of which is shrouded in mystery and confined to a special few. Of course, each misassuming party is aware of the other's existence. But the photo-reporters are wont to dismiss the 'high artists' as impossibly arcane, blind to life's realities; and the 'high artists', with many a wry smile, consign their more numerous fellows to hickdom.

This state of affairs requires elucidation. For the merest glance at the contemporary photographic scene reveals a variety, almost a maze, of aims and achievements, and any degree of familiarity with the subject's history should push the point home: photography is not, and never has been, a single, take-it-for-granted activity nor a magical turn, but rather a range of enterprises with legitimately distinct (even, on occasion, opposed) motives and with diverse stratagems and procedures.

I suppose there must be a time lag between the appearance of a medium, a practice, a discipline, and the emergence of sophisticated explanatory methods. Yet, in this case, at the beginning and for some while thereafter it may well have seemed that the genuine article was imminent. The dissemination of technical know-how was carried on amidst earnest and often lively debates about photography's aesthetic, social and political purpose and value. What truths can, could, ought photography to tell? How much room might the medium allow for imaginative manoeuvre? These questions preoccupied intelligent men and women.

However, the very forces that once prompted the discussion of means and ends together later conspired to curtail thoughtfulness and to frustrate the traffic in ideas. We are only just emerging from long years of obfuscation and silence. In place of that exchange of practical knowledge which was necessary for the substantiation of the new medium, and upon which its very identity depended, secrecy has become the rule: professionals are jealous of their experience, for obvious reasons, and tend to believe that their status in the eyes of the public at large is enhanced by common ignorance of photographic devices.

Books on photography abound, but they rarely illuminate.

One need only look over the pseudo-accounts of 'focal length'; one need only consider the advice of 'experts' on 'composition' – the simplistic scheduling of orders of interest, the genuflections before the 'Golden Mean' (a largely mythical system of proportions that careless historians of the older visual arts have palmed off on us); one need only notice a persistent unwillingness to provide for the ways materials behave in different circumstances, to register the scale of the exegetical failure.

There is a plethora of avowedly 'technical' treatises around, and these have had their own complicated evolution. They underpin the photographer's claim to respectable standing in the community of arts and sciences. And yet, though painfully studied at the schools and colleges, they have little if any place in actual practice. Typically they invoke, or half-invoke, or refer to, the principles of optics (as a rule, I should say, the optics of an earlier age); they dabble in mathematics and chemistry. But the business of producing meaningful images is so far outside their brief that their descriptions of processes and their recipes almost invariably stifle the operative ability they are claimed to foster and serve.

In fact, for all its variety and range, photography has been kept within narrower bounds than are reasonable – each branch of the thing developing in near-total isolation from its neighbours – by the crude or wilfully opaque nature of its verbal expression, by the lack of flexible and informed modes of discourse.

One may count on the fingers of a single hand the texts of today that are argumentative and genuinely educational – an essay on the consequences of machine-produced pictures, a speculative piece on the impulse to imagery itself, a survey of the functions of photography in the newspaper world. . . But these help to bring into focus areas of real ignorance and raise the level of hopes and expectations. This book has grown out of courses for art (in the main, graphic design) students, who are technically adventurous and committed to pictorial innovation. It is a *vade-mecum* of photographic effects, an anthology of striking and disparate images. While the authors eschew analysis of subject, they give uniquely detailed accounts of how the effects were achieved.

Conal Shields
Head of Department of Art History and Allied Studies,
Camberwell School of Art, London

Index